Focus On Clo
and Macro
Photography

.017

The *Focus On* Series

Photography is all about the end result—your photo. The *Focus On* series offers books with essential information so you can get the best photos without spending thousands of hours learning techniques or software skills. Each book focuses on a specific area of knowledge within photography, cutting through the often confusing waffle of photographic jargon to focus solely on showing you what you need to do to capture beautiful and dynamic shots every time you pick up your camera.

Titles in the *Focus On* series:

Focus On Close-Up and Macro Photography

Clive Branson

Focal Press
Taylor & Francis Group

NEW YORK AND LONDON

First published 2013
by Focal Press
70 Blanchard Road, Suite 402, Burlington, MA 01803

Simultaneously published in the UK
by Focal Press
2 Park Square, Milton Park, Abingdon, Oxon OX14 4RN

Focal Press is an imprint of the Taylor & Francis Group, an informa business

Notices
Knowledge and best practice in this field are constantly changing. As new research and experience broaden our understanding, changes in research methods, professional practices, or medical treatment may become necessary.

Practitioners and researchers must always rely on their own experience and knowledge in evaluating and using any information, methods, compounds, or experiments described herein. In using such information or methods they should be mindful of their own safety and the safety of others, including parties for whom they have a professional responsibility.

Product or corporate names may be trademarks or registered trademarks, and are used only for identification and explanation without intent to infringe.

Library of Congress Cataloging in Publication Data
Branson, Clive.
 Focus on close-up and macro photography / by Clive Branson.
 p. cm. — (Focus on the fundamentals)
 1. Macrophotography. I. Title. TR684.B73 2013
778.3′24—dc23
 2012024386

ISBN: 978-0-240-82398-0 (pbk)
ISBN: 978-0-240-82407-9 (ebk)

Typeset in Futura BT-Book
Typeset by: TNQ Books and Journals, Chennai, India

Printed and bound in China by 1010 printing International Ltd

Dedication

This book is dedicated to Cyril Branson, Janet Jury and to all aspiring photographers who have a passion they want to express and achieve. No matter the odds, never let it die.

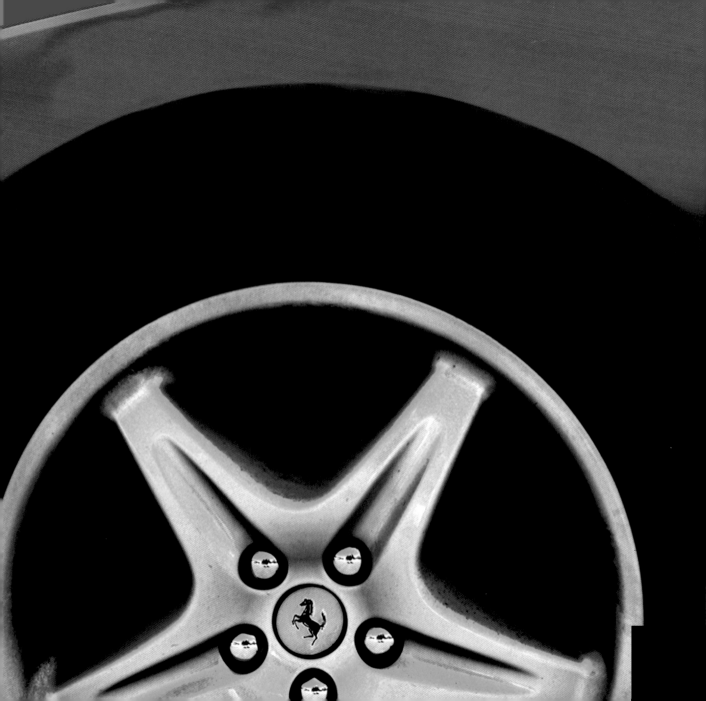

Contents

About the Author: Clive Branson

As far back as he could remember, Clive Branson wanted to be a photographer. After graduating from photography at Parsons School of Design in New York City, he realized that his ideas didn't equate with his budget. The dilemma persisted, forcing him to enter advertising as an art director. Two decades later, he is an award-winning art director, copywriter, and creative director with local, national, and international agencies. But his first love remains photography. His work has been published for national newspapers, global magazines, WPBS-TV, Canada Post, and the Canadian Tulip Festival. He lives and works in Ottawa, Ontario, Canada.

Acknowledgements

I would like to thank the following people who made this book possible: Stacey Walker and Cara St. Hilaire at Focal Press; Toni, Cathy, and Leslie (models); Tom and Mark at the Camera Trading Company; and Vincent Chisholm at Vistek Cameras.

Introduction

What's the point of close-up photography? The significance of close-up and macro photography is that it literally forces you, the photographer, to view things differently. It encourages curiosity and entices you to get on your hands and knees, to shoot something from an obscure angle, to take that extra effort for a shot. The reward is to delve into a microcosm: the delicacy of a flower's petals, the intricacies of a computer chip, the exquisite details of the human iris. Close-up/macro photography transforms the ordinary into the extraordinary.

Just take into account the average snap shot. Why do snap shots look so bland, particularly when compared to images by professionals? Why are the latter more captivating, more illuminating and powerful? How can you adjust your snap shot into a work of art? Good photography catches and holds your viewer's attention by allowing a subject to be seen in a whole new light. As you may discover, when you start shooting with macro, it can be even quite daunting, especially the specialized field of "super macro."

This book is an attempt to guide you, by using the techniques of close-up and macro photography, in rewarding ways. If this book enables you to take better shots, then life will become a journey of endless possibilities.

Chapter 1: What Is Macro Photography?

The Difference between Close-Up and Macro Photography

Although the technical name is *micro* photography (reduced to a very small size), the popular term is *macro* photography. What is the difference between close-up and macro photography? If you were to shoot a portrait, a close-up would be a shot of the person's face in full frame. A macro shot would be the detailing of your subject's eye or even the person's iris, enabling you the opportunity to focus on minute specifics less apparent to the naked eye. Close-up and macro photography are actually worlds apart, yet both highlight an intimate view of the subject without the necessity of showing the whole ensemble.

Close-up photography can be described as "filling the frame," whereas macro is the art of discovery; it's a bit like comparing a magnifying glass to a microscope. Both macro or *super macro* enable you to shoot small subjects true to size, or a little bigger. This is called life size or *1:1 magnification*. Anything farther away than this can be construed as close-up photography, not macro (even if you are using a macro lens). Macro does not involve zooming in; instead, you rely on the lens itself to magnify the image usually less than half-an-inch close. Close-up photography, however, can be achieved with any lens from zoom, telephoto, to fisheye or even wide angle. Macro is much more precise, and depending on your lens combination, you can get a ratio of 2:1 or greater, resulting in some amazing shots.

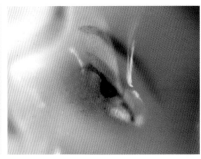

You may say, "What could I possibly use close-up or macro for?" Both styles can be used for four categories: fine art, editorial, advertising, and documentation (from showcasing, comparing, or examining objects to giving evidence, such as in forensics). Macro photography is particularly popular for capturing the miniscule details of insects and the intrinsically delicate beauty of flowers.

The Difficulty with Macro Photography

Macro photography is challenging because many of the rules that apply to other styles of photography simply don't apply to extreme close-ups. Using a standard or telephoto lens is not the same as using a macro lens. A macro lens requires more lighting, and you need to acquaint yourself with focusing techniques. In fact, despite the appeal of extreme close-up photography, mastering it can be somewhat difficult. With high magnification you will encounter marginal depth-of-field by fractions of an inch, limited light, and, because you have to use manual techniques, focusing can become a frustrating ordeal of hit-or-miss attempts.

The minimum focus distance from lens to subject:

Telephoto lens (200mm +) Distance: 2.5′ +
Compact camera Distance: 4.0″ +
Macro lens Distance: 1.0″ +
Macro lens with bellows Distance: −0.3″

Here are a few important issues I learned when transferring from using a regular or telephoto lens to a macro lens. Because of the extreme proximity between the lens and the subject, accessibility to light will be poor, as much of the light you will need will be blocked out, so try the following tips:

1. Increase your light source. For outside shots, use a reflector or ring flash. For indoor shots, add incandescent lighting or strobe lights.

2. Slow your shutter speed, though this may cause further problems, if photographing outdoors in the wind. You may have to bracket your shots (see 'Bracketing' in Chapter 2 p. 54).

3. Open up your aperture a lot more or increase your EV by several stops.

4. Always use a tripod for steadiness; that will ensure focus and clarity.

Another concern is getting accustomed with Manual mode—for the settings and the focusing. Focusing is one of the biggest challenges you will encounter in macro photography. To get sharp photos, focusing must be precise.

This seems obvious, but the closer you are to your subject, the lower your depth of field. A low depth of field means a limited range as to what can be focused. The advantage of using manual focus is that it allows you total autonomy to a wider context of sharpness; however, it is more time-consuming because you have to adjust all your settings to complement distance, light, and focusing—a difficult process in terms of achieving complete sharpness, because you are relying on your own assumption as to what is sharp in comparison to having the camera automatically do it.

The alternative is to dial your camera to Aperture mode. The camera sets the exposure while you simply concentrate on focusing. This is easier, but it doesn't allow you the flexibility to manipulate the exposure. And although autofocus provides the settings and focusing, it seems to become spasmodic when instructed to focus on specifics, either by being unable to differentiate between the front or back of the subject matter or obstinately focusing on the wrong detail or, worse, nothing at all. This is proof that cameras can't discriminate. They focus only on what is being aimed at unless there is a lack of contrast between the foreground and

background. The solution is either to find a more distinct area of contrast and switch on the focus lock or to focus manually and close down the aperture a stop to give more depth of field.

Autofocus may be ideal for creative photography, but not so much for documentation. Patience is a godsend. Despite the difficulties and special requirements of extreme close-up photography, those who dedicate themselves to it are rewarded with unparalleled images and boundless investigation into alien territories. Macro lenses can be very expensive, so let's examine some affordable alternatives.

Extension Accessories for Close-Up Photography

If you can't afford a macro fixed focus lens, there are several alternative means of getting a closer shot of your subject. Here are a couple of choices to consider.

Auxiliary Filters (Close-Up Lenses)

An auxiliary screw-on, close-up lens is placed in front of your camera lens and acts as a *diopter* (or added focus adjustment), resulting in a closer focusing distance. It is a bit like putting reading glasses over your lens. These come in ratios of +1, +2, and so on. They can also be stacked so you get a +1 +2 = +3 magnification or higher. It sounds great and they are relatively inexpensive, plus they don't require any exposure corrections, but the magnification is only marginal.

With most close-up lenses, the strength of the focus is in the center of the lens rather than around the perimeters. If you want complete picture focus, leave a wider frame and crop it later.

50 mm regular lens

50 mm with a +3 CU lens

50 mm with +1 +2 +3 CU lenses

35 mm macro lens

35 mm macro with a +3 CU lens

35 mm with +1 +2 +3 CU lenses

Keep in mind that stacking two close-up lenses is possible; however, to yield a better result, the stronger one (the one with a higher diopter number) should be the one closest to the camera lens. Moreover, by stacking three or more close-up lenses you will need to use Aperture or Manual mode for focusing.

Extension Tubes and Teleconverters

Let me explain the difference between an extension tube and a teleconverter. Both look pretty much the same, but a teleconverter is designed to increase the focal length of a lens. An extension tube is designed to increase image size on the sensor—an attachment that allows the lens to get closer to the subject than it could normally accommodate without the need for optics. The principle is that every lens has a minimum focal distance as part of their characteristics. For example, you can't use a 50mm lens for super close-ups; it has a minimum focus distance of 1.5 feet.

An extension tube or teleconverter can reduce that minimum focal distance by 4 inches or more. Be careful about which attachments you use on particular lenses. A 25mm extension tube won't work with anything shorter than a 35mm lens because the focus zone is moved in so close and the front glass element on the lens will prevent you from getting that close. Another discrepancy is that teleconverters, typically made in 1.4×, 1.7×, 2×, and 3× models, will increase the focal length throughout the entire focusing range—from the minimum focusing distance all the way to infinity.

Let's say you are using a 100mm lens that can focus from 12 inches to infinity. With a 2×-teleconverter, you could still focus from 12 inches to infinity, but the image would be twice as large. With the same lens and extension tubes, you could focus to 10 inches, 6 inches, or closer, depending on how many millimeters of tubes you place between your camera and lens. The image size would be magnified exponentially, but you would lose the ability to focus on a distant object. It is paramount that you keep the subject parallel to the film plane to assure uniformed sharpness.

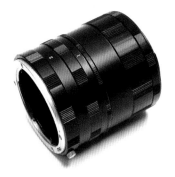

Bellows

Bellows look like flexible accordion attachments. There focal range depends on how close you physically position the lens to the subject, allowing you to control the lens distance from the body. One end of the bellows fits into the camera, whereas the other screws into the lens. How much magnification this extra extension will give you depends on the focal length of the lens used (50mm, 150mm, macro, etc.). Bellows of different sizes comply to different magnifications ranging from 10mm to as much as 200mm. You can avoid the laborious procedure of trying various teleconverters by just using a bellows. Just like extension tubes, bellows do not alter the image quality of the lens because they do not have an optical system. Instead, they can give you a magnification ratio up to 6:1, but the depth of field is very limited and focusing needs to be precise. I use bellows on my 50mm macro lens. They are inexpensive and an essential piece of equipment for extreme close-up photography. With bellows you will need a focusing rack and pinion rail and an adapter ring to screw into your camera body.

The depth of field is marginal, so you will need to rely on aperture or manual mode for focusing, as the autofocus will be inoperative.

Choosing the Right Camera and Lenses

Generally, the more you want to magnify a subject, the more it will cost you. When it comes to digital single-lens reflex (DSLR) camera lenses for macro and close-up photography, the main factor you

will need to consider is the type of magnification you want. Simply taking a close-up shot with a regular lens is not enough. As mentioned previously, certain lenses don't have the magnification desired. Other lenses are just too expensive. It's a subjective decision. Personally, I use Olympus cameras with the following lenses: a Zuiko Digital 35mm 1:3.5 macro lens, a Volga 50mm 2.8 macro lens, a Zuiko Digital 200mm 1:2.8 telephoto lens, and a Zuiko Digital 40-150mm 1:3.5 zoom lens.

If you can afford it, get a fixed focal length macro lens. How can you tell what a fixed macro lens is? First, read on the lens the magnification (1:1, 1:2, 1:3.5, etc.). Second, check the desired lens at a dealership, either by sampling it there or by renting it for the weekend and really testing it thoroughly. Look into the lenses by Sigma, Tamron, Vivitar, or Tokina. A new macro lens is in the range of $500 or more, but a used macro lens is worth investing in at half the price. Check out preowned macro lenses at camera exchange stores (reputable ones are usually recommended by camera store dealers as an alternative source).

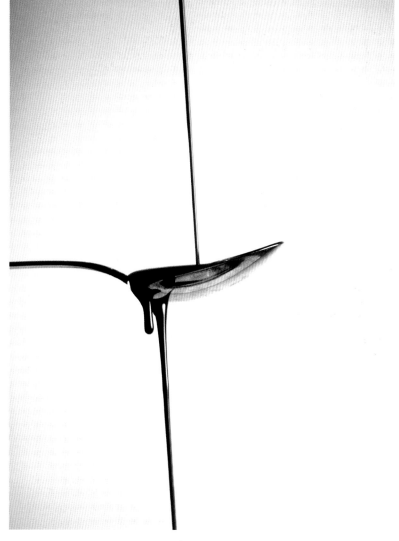

Chocolate sauce being poured onto a spoon

Make sure you pay special attention in selecting a lens specifically designed for macro (or micro) photography if you want to take extreme close-ups seriously. These are called micro lenses. Be careful not to get these lenses confused with macro zoom lenses, which vary in focal distances. How close do you want to get to the subject? What kind of photography are you doing? And how often will you be doing this kind of photography? It's pointless to get a fisheye lens if you are only going to use it occasionally. The same applies for macro. So do you want a zoom/telephoto lens that can give you close-up shots and be adaptable for other photography, or do you specifically want a macro lens for extreme close-ups? Do not be fooled by the macro setting on your camera. This will not bring you true macro results unless it is a genuine macro lens.

Cameras

Compact Digital Cameras

Most compact point-and-shoot cameras these days are equipped with a macro-like function. Simply switch your mode dial to "macro" (the flower icon). This will set you up for close-up shots, though not comparable to shooting with a real macro lens. Compact cameras are ideal for taking photos with the bare minimum of fuss and perfect for postcard-size and Internet pictures. Anything larger and you will need a compact camera with more than 10 megapixels (MP).

Compact Digital Cameras: Advantages

- Inexpensive, light, and compact.

- No accessories are required and easy to use with built-in flash and zoom lens.

- Image sensors range from 7 MP to 15 MP.

- Accepts removable and reusable memory card.

- Most models have at least three image-quality settings.

Compact Digital Cameras: Disadvantages

- Lower battery capacity (longevity is unreliable and the batteries must be changed regularly). This is particularly evident when subjects are viewed via an electronic viewfinder or LCD screen.

- Lenses can't be changed.

- Cheaper models have low-quality lenses.

- Lenses produce much greater depth-of-field compared to DSLR cameras, which means

selective focusing (throwing the background out of focus) is difficult to achieve.

- Hard to sometimes focus on (or even see) what you are shooting because of glare off the LCD screen.

- Delay between pressing the shutter and the picture being taken, known as shutter lag.

- Noticeable noise at higher ISO settings.

- No good for low-light photography.

Advanced Compact Digital Cameras

These cameras are, for the price and size, well featured and are available from 8 MP to 15 MP.

Manufacturers today have concentrated more on the development of compact camera zoom lenses than on the development of fixed focal lengths. Nevertheless, the quality of zoom lenses is quite remarkable and the only difference from an expensive compact digital camera to a DSLR arises when you enlarge an image.

Advanced Compact Digital Cameras: Advantages

- From 5x to 12x optical zoom lenses.

- JPEG, TIFF, and RAW file capabilities.

- Adjustments for color, contrast, and sharpness.

- Excellent quality lens.

- Accurate focusing and exposure reading.

- Increased ISO range.

- Increased white balance options.

- Manual exposure modes.

- Multipoint autofocus sensors to handle off-center subjects.

- Self-timer.

- Clip-on conversion lenses and filters.

- Image stabilization.

- Flash exposure adjustment.

Bridge Cameras (Super Zooms)

A bridge camera is a combination between a compact camera and a DSLR in terms of style and size. Cameras in this category have 10 MP to 15 MP sensors.

Bridge Cameras: Advantages

- Advanced feature sets similar to midrange DSLRs.

- Fixed but powerful zoom lens. A range of up to 12x.

- Manual controls.

- Accurate framing of close-up subjects.

- Digital preview screens 100% of the image to be taken.

- RAW format option.

Bridge Cameras: Disadvantages

- Offers less control of depth of field than DSLR sensors.

- Susceptible to more noise.

- No interchangeable lenses.

- Small ISO range.

- No optical viewfinder.

- EVF and LCD screens are low resolution.

- Difficult to focus manually.

- High drain on batteries.

Digital Single Lens Reflex Cameras (DSLRs)

These cameras offer the widest range of lenses with prices that range from moderate to stratospheric. Entry-level DSLRs provide 8 MP to 12 MP (though some of the quality is dubious), whereas professional DSLRs provide almost unlimited quality and impressive megapixels. Although some cameras stress a remarkable quantity of megapixels, don't be misguided. The number of megapixels doesn't necessarily make a superior camera or even a better-quality image. There are DSLR cameras that produce 10 MPs and are superior to other cameras that offer 15 MPs.

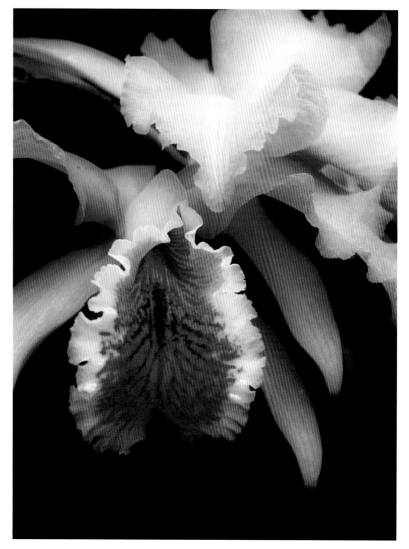

A beautiful Ada Perry Spuria Iris

DSLRs (Entry to Midlevel): Advantages

- Sophisticated light meters and autofocus lenses.

- A wide spectrum of program modes.

- Good for almost any light condition.

- Includes RAW file format.

- Wide ISO range.

- Separate body and lenses can be compatible, including macro lenses.

- Depth-of-field preview button.

- Ample range of file size and compression settings.

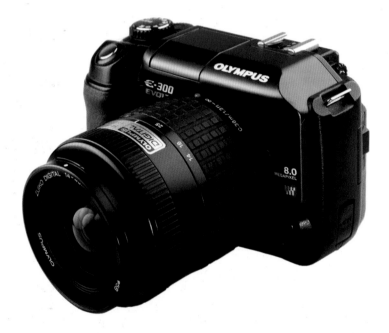

DSLRs (Entry to Mid-Level): Disadvantages

- Heavier and bulkier than compacts.
- Investment in computer equipment/Photoshop almost a necessity.

DSLRs (Advanced): Advantages

- Advanced light-metering systems.
- Camera details that cater to specific professional applications.
- Extended ISO range.
- Advanced white balance options.
- Fast autofocus.
- Dual memory card slots.
- Fine adjustment controls for sharpness, contrast, saturation, and color tone.
- High burst rate of more than 20 frames.
- Increased tolerance to extreme temperatures.
- Manual overdrive of automatic functions.
- Integrated sensor-cleaning system.

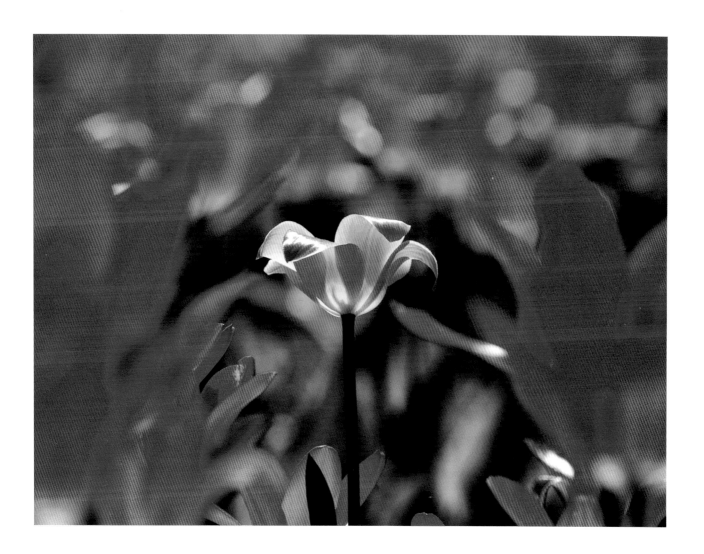

Lenses

The Telephoto

I couldn't imagine photographing flowers without my telephoto lens. It is a great lens, providing the photographer with a range of focal lengths from 80mm to 800mm. Two outstanding qualities of the telephoto are its inherently shallow depth of field and its ability to compress or flatten the perspective, giving you captivating shots by softening the foregrounds and backgrounds and, using a wide aperture such as f/2.8, blurring out superfluous distractions around the subject. On the other hand, the minimum focusing distance of these lenses restricts the photographer from getting too close to the subject, usually no closer than 3 to 6 feet. Because of the weight of each lens, a tripod is fundamental for stability. Because the focal lengths of these lenses are longer than normal, the shutter speed needs to be increased to reduce camera shake (1/200 second or more).

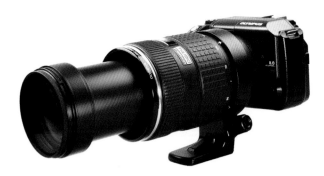

The Macro

The macro lens is available in a variety of focal lengths, from 35mm to as high as 300mm. The significance of the macro lens is that it can accommodate you with shorter focal distances than you can get using a normal lens—in some cases, as close as 0.8 inches. The macro lens, with its shorter focal length, can provide higher sharpness, but all macro lenses have a shallow depth of field because the objective is to get as close as possible. Make sure the lens has a maximum aperture of f/2.8 for ultimate magnification.

35mm to 65mm

Because you have to get so close to your subject, these lenses are not the best for photographing insects in the wild, but they are irreplaceable for any other type of close-up photography, including floral.

70mm to 105mm

These macro lenses are probably the most popular because they don't cost that much more than the 35mm to 65mm lenses and offer about twice the working range.

120mm to 200mm

The 200mm macro lens is expensive; however, it is reliable and will give a 1:1 life size magnification from a distant range that won't scare off the subject or interfere with light.

Zoom Lenses

The problem with zoom lenses is that they don't get close enough for the full macro range, although this is gradually changing. When selecting a zoom lens, know exactly what you want the lens for and inquire if it is the right choice. Macro lenses are capable for several purposes including close-up as well as portraiture.

Tripods

Close-up of waterfall shot at 1/30 sec.

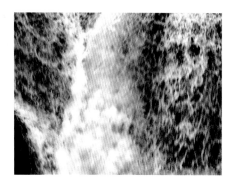

Close-up of waterfall shot at 1/500 sec.

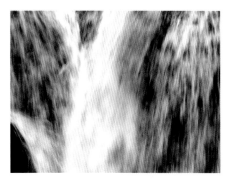

Close-up of waterfall shot at 1/250 sec.

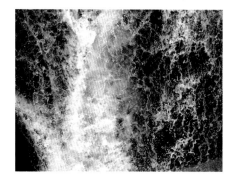

Close-up of waterfall shot at 1/1000 sec.

I would have had much more difficulty with the precise variations of the flow from this waterfall without the use of a tripod.

Can you walk effectively on one leg? Maybe, but it's not recommended because of how unsteady it is. Neither is shooting macro photography without a dependable tripod. This is particularly important when supporting heavy telephoto lenses or using focusing rails. The steadier your camera, the better the results. Sounds obvious, but it is amazing how many photographers don't rely on this key accessory. So what does one look for in a tripod?

It is necessary that a tripod is adaptable to allow you to shoot from any level or angle. Because the majority of your close-up photography will concentrate on flowers, nature, or tabletop displays, you want a tripod that isn't cumbersome to maneuver or unfold and can be lowered to ground level. On some tripods, you can remove the center post and reinsert it upside down, but doing so is time consuming and this type of setup is very awkward to shoot from. Instead, find a tripod whose legs splay all the way out and still permit your camera to be as low as 5 inches from the ground. An even better tripod is one with a bendable center post. This can be adjusted for any bizarre angle.

For tabletop shots, one suggestion is the ministand from Canon. It is less than 2 inches from the table surface and provides me with any degree of straight angle but, unfortunately, not from a perpendicular angle. Another option is the Gorilla pods from Moby, with their flexible legs that you can manipulate to any direction. This is reliable for all but heavy lenses.

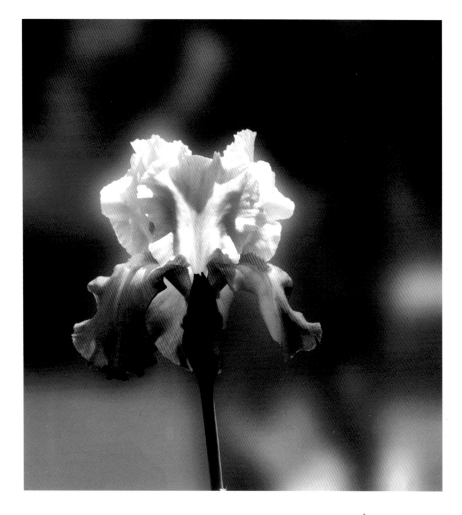

Irises have long stems, and this shot couldn't have been accomplished without a reliable tripod because there was a persistent breeze. It was just a matter of waiting between gusts of wind to take the shot.

Tripod heads (the connection between the tripod and your camera) come in a variety of styles: fluid video heads, pistol-grip, ball-jointed heads, and two-way adjustable heads to name a few, so it might be best to inform the camera dealer of the intended usage and have the dealer suggest a suitable tripod.

I say this because on some of the professional products, the head is bought separately.

I wouldn't recommend mono-pods because the slightest movement, even your heartbeat, can move your camera if it isn't securely harnessed. Although monopods are light and,

consequently, more convenient to carry around than three-legged tripods, you may discover that they are better when pressed against something more durable for support when shooting, like a wall. Put it this way: when looking for a tripod, don't buy a poodle when you could get a rottweiler.

Flash and Reflectors

Light is everything when it comes to photography. It sets the mood and it enhances the most important features of what you want to shoot.

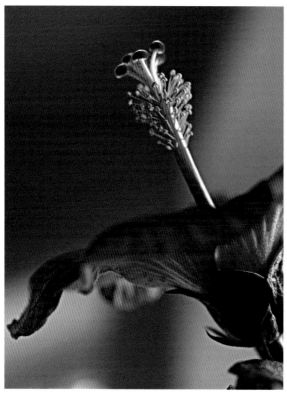 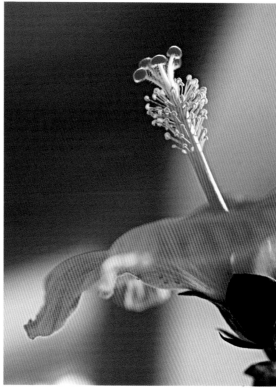

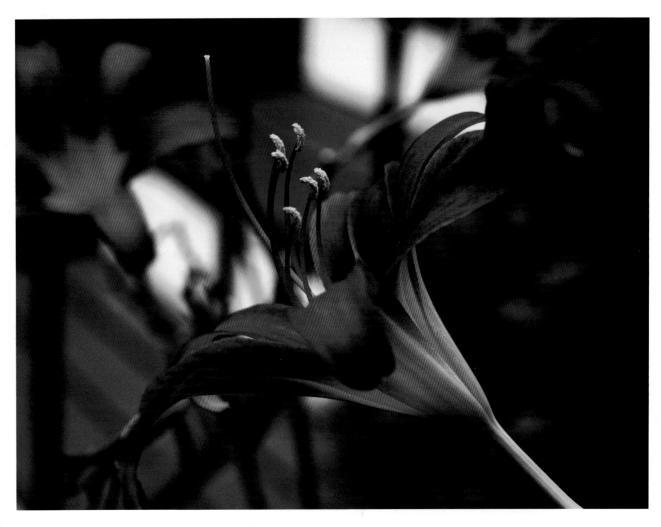

I took this shot of an Adenophora Campanula right after a thunderstorm. The fill-in flash allowed me to articulate the foreground details and drain out the distracting background.

Flash

Obviously, there are scenarios whereby there isn't enough light, so a flash or a reflector is indispensable. The trouble with flash furnished in your camera is that it is inflexible and when it comes to close-ups, the flash unit is usually too close (and too powerful) for the distance, resulting in burnout spots or complete overexposure. An appropriate distance for built-in flash is between 3 and 15 feet away, so it isn't ideal for close-up photography.

The way it works is that the shock of light from the electronic flash must travel to the subject and bounce back to the camera. Consequently, only a small portion of the flash is actually utilized. If you are closer than 3 feet for close-ups and still require extra light, either turn off the flash unit (or if you cannot turn it off, place your finger or black tape over the flash unit) and use a supplementary light source instead such as a handheld flash (flash gun), or place tracing paper or even cotton fabric over the flash head to diffuse the harshness of the flash. The advantage of a handheld flash is that you can position it at various angles or have its flash bounce off a reflector toward the subject.

If the outdoor light is too bright, usually during the midday sun, you may be combating glare. You can avoid this by shooting away from the sun's direction and using a dark diffuser to absorb some of the harshness of the light (be careful not to disturb the light with your own shadow). You may also encounter high-contrast light where your subject is exposed to extreme light and obscured by shadow. This is where fill-in flash is ideal.

Powerpack Flash

Distance	Aperture
1 feet to 4 feet	f/22
4 feet to 7 feet	f/16
7 feet to 10 feet	f/11

WHEN TO USE FLASH

- To highlight a selected area for increased sharpness.
- To brighten a subject in dull light.
- To stop motion caused by wind or for high-speed photography.
- To add light in shadow areas on a bright day.
- To increase the contrast between the subject and the background.

Fill-in Flash

Fill-in flash is used to highlight shadowed areas without jeopardizing the lighter areas, giving a sense of normalcy to the scene. With this in mind, fill-in flash should never be stronger than the primary light, such as the sun, for it defeats the purpose and replaces the sun as the primary light.

I liked the color combination of this old nut and bolt, but too much was in shadow. I was about 8 inches away, so I taped nylon over my flash to avoid any glare.

Steps to Take When Using Fill-in Flash

1. Set your flash unit to the proper ISO designation, like 100.
2. Set the camera shutter speed to the standard 1/60 of a second or slower.
3. Be cognizant of the distance between the subject and the flash. To help, the distance is found on the focusing scale of the lens's barrel.
4. To determine flash output for the distance, set the flash unit for manual operation. Try setting the lens aperture at f/16 or one stop down from the smallest aperture. Bracket the following shots by changing the f-stop at half stop intervals. Otherwise, set your camera to Aperture mode to ensure that the background is correctly exposed and the image comes out evenly lit. If you want the foreground to pop, darken the background slightly (by using a smaller aperture or higher shutter speed).

Reflectors

Reflectors come in a variety of shapes and sizes. The bigger the reflector surface, the more light is bounced back to your subject. The different colors of reflector surfaces all change the color and quality of light.

Silver

A silver reflector reflects the most amount of light and doesn't change the color of the light. This is particularly useful in studio photography, although there is no harm in using it outdoors.

Gold

A gold surface on a reflector reflects a lot of light, but not quite as much as the silver-coated reflector. The gold surface, however, adds a warmer tone to the light for a softer touch that is ideal for floral photography, giving flowers a richer hue of texture.

White

A white surface reflects less light than silver or gold, but it produces a soft even light. This works well both in the studio and outdoors and is great for portraitures.

Black

When you want to suppress the harshness of light, try using a black reflector. Unlike silver, gold, and white reflectors, black reflectors absorb light.

Of course, you can always make your own reflector. Simply cut a circular piece of cardboard and wrap it with aluminum foil. Otherwise, a white piece of paper, glossy paper, or even a mirror can do the trick.

Ring Flash

A ring flash is a circular flash unit that attaches to the front of your lens. Designed for added light for close-ups, it can produce flat, shadow-free light that is excellent for cataloging and documentation, but it can be disappointing for creative shots. To overcome this drawback, some ring flashes have more than one flash tube. Nevertheless, because the light is so close to the subject, it allows you to shoot at really small apertures (f/16, f/22) for greater depth-of-field and at a faster shutter speed of between 1/125 a second to 1/250 a second.

Chapter 2: Composition

Before You *Even* Take a Shot, Consider the Following:

- What do you intend to do with your shots?
- Who is your audience?
- Do you want to get your images published?
- Do you want your shots enlarged or exhibited?
- How should the image by composed?
- Should it be highly detailed or abstract?

- Should the focus on the image be on the color, the shape, or the texture?
- What would it look like in black and white?
- What should the relationship be between the subject and the background?
- How relevant is the background? Does it overpower the main subject?
- Are there any unattractive shadows dominating the picture?
- What other angles should I shoot it from?

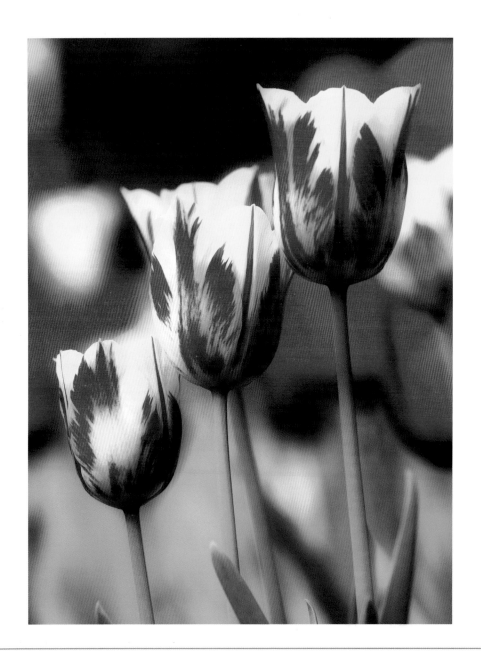

Your Eye *Isn't* the Camera's Eye

Too frequently photographers will be disappointed when a photographic image does not live up to their expectations. The picture wasn't close enough, bright enough, focused enough, focused on the wrong thing, or just didn't project the emotion you craved. You must be careful how you interpret a scene or subject. It is important that you recognize that most of the work involved in creating a good shot is done beforehand.

The essence of seeing is just that, to interpret. Subconsciously, we often only take in what we want to focus on. For example, we'll admire a beautiful flower but are oblivious to the superfluous details around it, such as unsightly twigs and foliage. Our vision is a complex composite of eye and brain interpretation. We register an image, but the brain translates that image to suit whatever emotional and psychological factors are influencing us. In other words, our eyes see stereoscopically but our brains take the visual information from each eye and merge the two images into one. The use of the slight discrepancy between the two images defines depth. The camera, however, does not function this way. It can't discriminate what it focuses on. The camera doesn't care what is important and what isn't. You can't afford to rely solely on the camera and must take that responsibility through the careful process of four key areas:

1. Framing
2. Composition
3. Foreground versus background (exposure)
4. Analyzing light

Composition is vital for achieving good photography. Even when correctly exposed, a photograph can still look bland if the composition is wrong. What you choose to leave out of the picture is as important as what you leave in. When showing your photographs to someone, understand that it is human nature for a viewer to zero in on the brightest matter within a scene. The next object of interest will be sharpness and, finally, color.

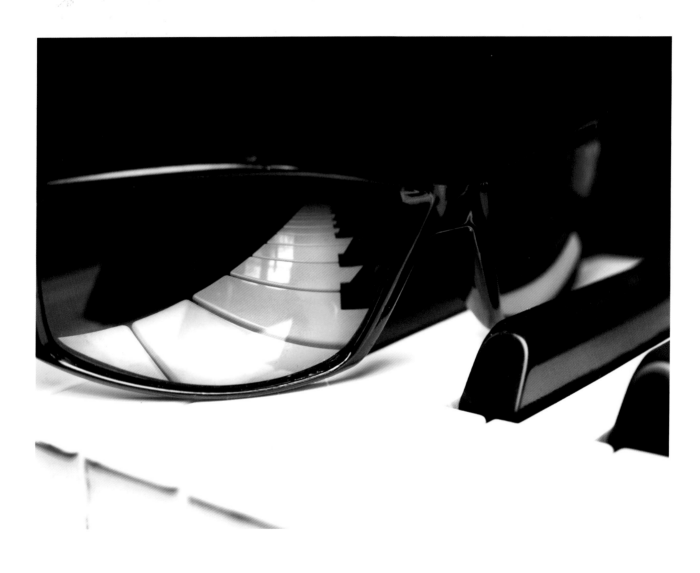

Framing

Focus the Mind as Much as the Camera

Too many people come up to, say, a flower, and shove their compact cameras as close as possible at a 45-degree angle and snap. Then they go on to the next victim. Don't just shoot at first sighting. It is recommended that you mentally frame your composition before shooting. To get the "Wow!" factor, isolate the subject and discover what its uniqueness is, as demonstrated by the sunglasses on the piano. Neither the sunglasses nor the piano alone would have been an impressive shot, but combined at a unique angle, the picture is given a new dimension. Always consider various angled options, even from behind the subject matter.

This is what composition is all about: it refers to the arrangement of elements within the frame. The composition of a photograph is the means a photographer has to articulate the idea that motivated the shot in the first place. Composition extends the influence of the photographer, enabling him or her to capture the viewer physically, emotionally, and intellectually. When you look at a scene, what draws your eye? Now consider how you would like to see it up close. How would you like to see it printed? When you've taken a shot, do others see what you initially sought after? If not, the photograph hasn't been a success.

Composition is the appeal of a design, rather than the beauty of the individual member, that helps make the subject photogenic. Many factors can affect a photographic image such as lighting, the camera's settings (such as f-stop, shutter speed, and ISO), the quality of the camera's lenses, filters, and the tripod. But more than these is the photo's composition, the arrangement of the elements within the image.

Guidelines for Composition

1. Identify the primary point of interest before you begin taking pictures.

2. Keep it simple. Don't clutter the picture within the frame, for it only weakens the final result.

3. If you wish to isolate your subject but cannot find a suitable angle, manipulate the depth of field by blurring out the foreground and background by using a wider depth of field (DOF) or a higher lens.

4. Patterned lines and shapes appear more dynamic if you angle your shot in a diagonal fashion rather than parallel to the edges of the frame.

5. Negative space is very effective for both balance and impact.

6. Do you want the subject completely in focus (need to use Aperture or Manual mode) or do you instead want to zero in on an aspect of the subject (Autofocus mode)?

This shot was a close-up of a soda drink for the "Beverage" section of a restaurant menu. Here is an example where close-up photography enables the viewer a perspective that is much more tantalizing than a regular medium or long shot. You can almost taste the content—that's why most food shots are close-ups.

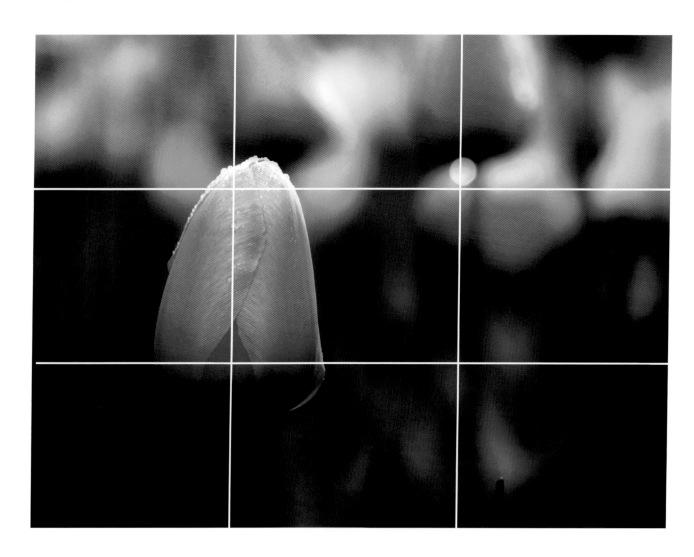

The Rule of Thirds

If you want to have balance, place your subject so that it is occupying a strong position in the frame. Instinctively, we tend to place our main subject dead center in our photos, but to make a photograph more compelling, apply the rule of thirds. When you are about to shoot, picture a grid splitting the image into thirds both horizontally and vertically. The key subject of the picture's focus should be placed at one of the intersections of the vertical and horizontal lines. This method allows a sense of tension and energy and helps to pique the viewer's interest. The basic principles of composition don't need to be followed like a carbon copy. It is up to your discretion, particularly concerning close-up photography, whether the rule of thirds should apply.

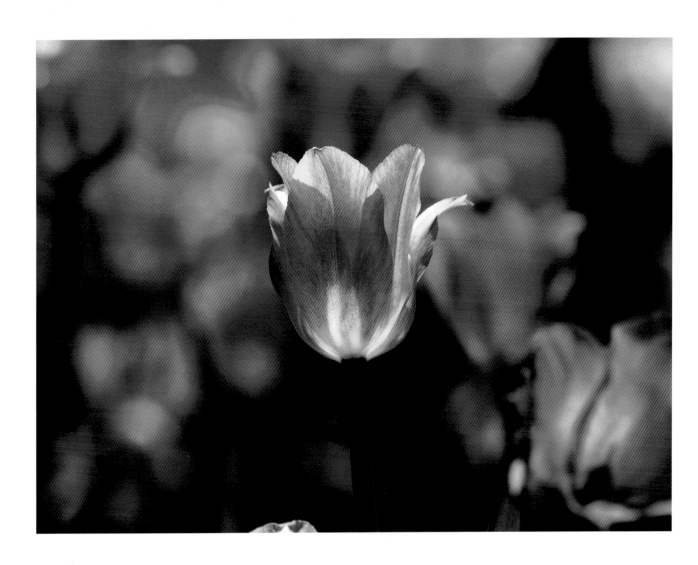

Depth of Field

Today, most digital cameras are so sophisticated with automation that they seem capable of doing everything for you. Unfortunately, this often isn't the case. There are too many difficult lighting scenarios that confuse the camera's calculations. Let's begin with depth of field (DOF). Did you know that barely 5% of what we see is actually sharp? Again, the mind deceives us. By having our eyes scanning in such quick succession, it appears as though everything is in sharp focus. Depth of field is all about the focusing of space. The focusing boundary is determined by three factors:

1. The aperture setting (f/number)

2. The depth of field

3. The focal length (25mm, 50mm, 150mm, etc.)

Exposure can be terribly technical and confusing, so I'll keep it as simple as possible. Aperture is the term for a series of numbers from 2.8 to 22 that correspond to a specific opening in your lens, and these openings are called f-stops. In photographic terms, the 4 is called f/4, the 5.6 is f/5.6, and so on. An f-stop is a fraction that indicates the diameter of the aperture (measured by halves). The f stands for the focal length of the lens, the slash (/) means divided. The primary function of these lens openings is to control the volume of light that reaches the sensor during an exposure. The smaller the f-stop number (f/2.8 being the smallest though there's an f/1.2 from Canon and a Nikon f/1.4), the larger the lens opening, and the larger the f-stop (f/22 being the largest), the smaller the lens opening. Look at it this way: when increasing the f-stops from f/2.8 to f/22, f/4 is double the diameter of f/2, f/5.6 is double f/2.8, f/8 is double f/4, f/11 is double f/5.6, f/16 is double f/8, and f/22 is double f/11. Conversely, the opposite applies.

I shot this tulip at f/8 with a telephoto lens. If I had shot it at f/22, everything, including the background, would have been in focus, distracting the key focus—the foreground. The smaller f-stop allows a soft, blurry background, ideal for such a delicate flower.

f1.8 to f4 provides limited depth of field.

f5.6 to f11 provides a mid-range depth of field.

f16 to f22 provides maximum depth of field.

It's easier if you just remember that the larger the f-number, the greater the depth of field of focus. So when you read or hear someone telling you to "open your lens wide or up" to blur out the background, that person is referring to a smaller f-number. When you shift from a small aperture number to a larger one, you are reducing the size of the opening (aperture) and "stopping the lens down." Subsequently, the choice of aperture directly affects the amount of sharpness with the overall image.

Six Ways to Maximize the Depth of Field in Your Image

1.

Use a lens with a short focal length.

2.

Focus on a distant subject. If you're trying to focus on the foreground and background, focus on the background rather than the foreground and you are more likely to get both subjects in focus.

3.

Use the smallest aperture if possible (from f/11 to f/22 if you can).

4.

Try to line up the subject's main features so they are plane and uniform to the camera to make the most of depth of field.

5.

Be cognizant of proportions. The closer you get, the more emphasis is placed on the features closest to your lens. You don't want to blow them out of proportion.

6.

With macro photography, simply pressing down on the shutter release button can cause unwanted image blur. To avoid camera movement, set the timer release so the camera is capable of shooting without physical disturbance or get a shutter release cable. Alternatively, shoot at a higher shutter speed, such as 1/200 or higher.

10 Steps to Take If Your Images Are Not Sharp

1.

Make sure your lens is focused on the right part of the composition.

2.

Double-check your shutter speed. If the shutter speed is too slow for handholding or if the subject moves, the image will blur.

3.

Be gentle with your shutter release. If the photographer jabs the shutter release, the camera will wobble. Use the self-timer or a camera release in order not to move the camera.

4.

Turn on the vibration reduction (or "image stabilization") mode. Turn it on under difficult lighting conditions, but turn it off when using a tripod.

5.

Use a shorter lens and get closer or use a larger lens farther away.

6.

Don't shoot your lens at its widest aperture unless that's the desired effect.

7.

Use your focusing aids and focus manually. The "aid" is usually an audible or visual focus confirmation when the subject is in focus.

8.

Use your autofocus (AF) lock, but be careful with this because it also locks the autoexposure.

9.

Watch your ISO speed.

10.

Turn off the noise reduction only if it interferes or alters the sharpness of your pictures.

Overexposure is generally frowned upon simply because it is so difficult to correct by post-processing on a computer, but there is the exception, especially when you seek to create an aesthetically pleasing shot as demonstrated by the images of chess pieces seen below. The first image was taken at the correct exposure, but to get a more interesting shot, I pushed the exposure for excessive light, bleeding out the background to place more emphasis on the foreground.

I find that digital cameras get the exposure more often correct if the camera's autoexposure setting is set to underexposure by about two thirds of a stop. I also find that the exposure is more likely to be correct if the camera is also set to automatically bracket the exposure by about two thirds and the remaining third at a nominal 0 stop.

To get the best focus, use your camera in the M (manual) mode. To see the difference, try this test. Photograph your subject using AF (autofocus), then use A (aperture) and finally M (manual). Set your lens at f/5.6, adjust your shutter speed until the camera's light meter indicates a "correct" exposure, and take the photograph. The differences should be apparent. Manual mode is easier for focusing on what you want, but it makes it more difficult to get the correct exposure. A handheld meter is very useful; otherwise it is by trial and error.

A rule of thumb as to the optimum aperture for maximum sharpness is to stop down only three stops from the widest aperture. Therefore, a lens with an aperture of f/2.8 will probably be at its sharpest when stopped down at f/8.

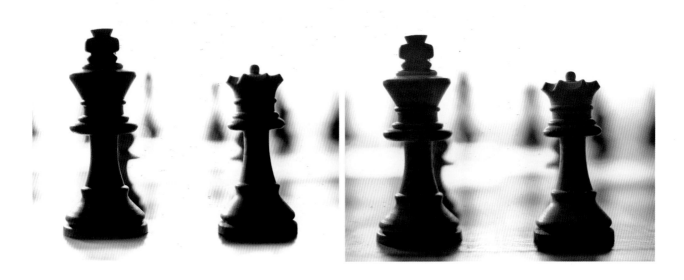

Depth of Field Preview Button

A good tool in determining what is and isn't in focus is the depth of field preview button. While looking through your viewfinder, press the DOF button to analyze your depth of field. It confirms whether you have chosen the right aperture. When you press the DOF button, there will be a decline in light transmitted into the viewfinder. Don't worry so much about this; concern yourself with what is and isn't in focus. If you are not content with the focus, keep the DOF button engaged and start opening the lens by small increments. As you do this, you will observe that areas become more defined (or blurred out depending on what you desire). Once you arrive at an aperture that suits the effect you like, adjust your shutter speed until the camera's meter indicates a correct exposure and shoot.

This is a shot of a CD wrapped by reflective silver paper. There were numerous reflections, so I couldn't use autofocus because the camera would be too confused as to what to focus on; instead, I dialed the camera to Manual mode. The depth of field preview button helped to make the focus as precise as possible in a complex scenario.

Bracketing

There are some scenarios in which the combination of light and dark is too complex to take control with confidence. In these cases, it is a good idea to bracket your photos, which is simply the process of taking several pictures, each with a slight variation of the exposure, so at least one of them will look the way you want. Use your camera's autobracketing feature. Turn it on and it will take three pictures in quick succession when you press the shutter release. The pictures are taken in sequential order: a picture taken with optimum exposure, a picture adjusted in, and a slightly overexposed image for your review. Otherwise, you can manually adjust the EV settings.

Bracketing is an important technique used to ensure that the best possible exposure is achieved. A standard bracket requires three frames of the same scene. The first is at the recommended metering, the second usually at half a stop over, and the third at half a stop under.

EV -0.7 EV 0.0 EV +0.7 EV post-produc-tion: combination of -0.7 and +0.7

Shutter Speed

There are two important roles regarding shutter speed. First, it controls how long the image sensor (the equivalent to film) is exposed to light. Second, it determines how sharp you want to capture your subject. This is crucial when photographing flowers or insects, because the majority of time you will be combating with the wind or trying to seize a busy insect. I have spent agonizing moments waiting and waiting and waiting for a breeze to subside so that a flower would stop dancing around. What makes it complicated is arresting their movements and keeping the correct exposure. And it is almost pointless using autofocus—it causes the camera to keep on focusing in and out with the swaying of the flower—so stick with either Aperture or Manual mode. Conversely, if the wind won't subside, try experimenting with a long shutter speed (anywhere from 1 second to 1 minute) so that the flowers in motion look like lips of flames or to get that aesthetically pleasing dreamy, swirling effect.

Patience is a virtue, but there are alternative solutions to achieving

photographic nirvana in a persistent breeze:

- Either block the wind with your hand or body (as long as you don't leave your shadow over the flower while doing it), or use a white or black board as both a shield and reflector. Consider using a plastic, transparent umbrella.

- Use a transparent Plexiglas to block the wind, though the wind can circumnavigate around the glass and cause the flower to move.

- Place a tripod-held clamp clip onto the flower for steadiness. There is a product called a Wimberley Plamp that is specifically designed for this role.

- If there is sufficient light, use a faster shutter speed (at least 1/250) in combination with a small aperture. Also use an electronic handheld flash to freeze motion.

- Use a CubeElite. This is a large, square soft box that can cover the flower (if it is isolated), allowing protection against wind. It is light enough to permit natural light to pass through and you have optional slits as to where to position your camera.

- It may be tempting, but don't cut any flowers in the wild.

The rule of thumb to use with focal length in non–image stabilized situations is to choose a shutter speed with a denominator that is larger than the focal length of the lens. For example, if you have a 50mm lens, 1/60th is probably okay, but if you have a 200mm lens, you'll probably want to shoot at around 1/250. I came across a bog and some leaves swirling in a whirlpool current. I left the shutter speed on for 1/15 of a second. I still wanted the sense of motion without the distortion of the leaves in the swirl.

The speed of the shutter is measured in fractions of a second, but even long lapses of exposure can make a significant difference to the outcome. The longer the exposure, the more light penetrates through, so to avoid overexposure you have to compensate with the settings or EV levels. Otherwise, set your camera either to "S" (shutter priority shooting) or "A" (aperture priority shooting) and check your autofocus (AF) meter reading. Overexposure is when the AF light is blinking, so increase the aperture value (f-stop number). If underexposed, the opposite applies. If it still blinks, set the ISO sensitivity to a lower value. The level of noise/grain is in conjunction with the level of the ISO value: the greater the ISO number, the greater the risk of noise.

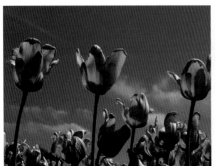
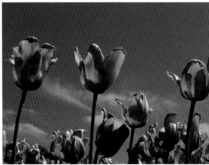
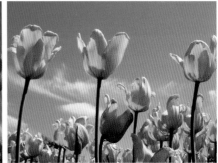

Always try to use a tripod and bracket your shots. In an effort to get the most precise exposure, one frame should be exposed at the meter reading. Other frames can be either underexposed or overexposed. To bracket, alter the f-stop or the shutter speed, but only *one* of these should be changed for any series of bracketed shots. Turn the exposure compensation dial (EV) to (+) for overexposure and (−) for underexposure until you are satisfied with one of the alternatives. Also try sandwiching three shots together (the meter reading shot plus an under- and overexposed shot). You'll discover that you can achieve some interesting results.

When using aperture priority to affect your shutter speed and you need more light, use a smaller numbered f-stop, and if you want to get a slower shutter, use less light and a larger numbered f-stop. It takes time to get accustomed to controlling the f-stop, aperture, and shutter speed; only constant practice will compensate this hurdle.

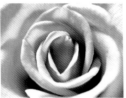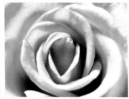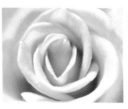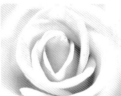

Correlation between Shutter Speed and Aperture

Shutter Speed	Aperture
1/1000	f/4
1/500	f/5.6
1/250	f/8
1/125	f/11
1/60	f/16
1/30	f/22

A Pro Stock car burning rubber at Luskville Dragway wouldn't have been half as intense without a powerful telephoto lens, such as a 200mm at 1/250 of a second. A faster shutter speed wouldn't have enabled me to capture the velocity of the spinning wheel without it freezing too much motion. Anything slower and the car would have been a blur.

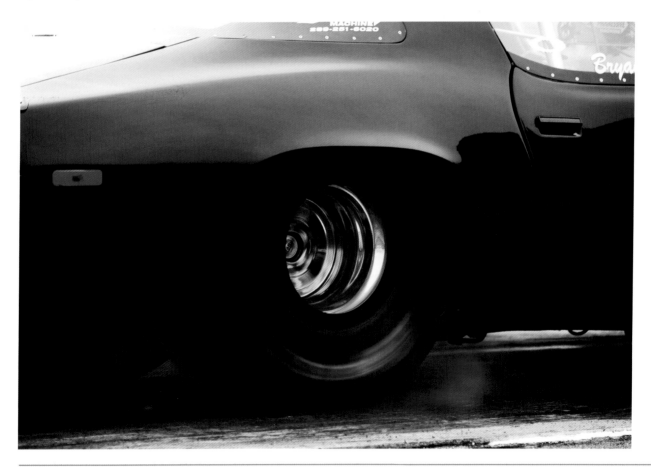

ISO

ISO stands for International Standards Organization and is the indicator of the sensitivity of the digital sensors. You will find most digital cameras are set up at 100 ISO. If you wish to go beyond simple shooting using only the shutter button, there are alternatives. For instance, use a lower ISO value with normal light and a higher ISO value to compensate exposure under darker conditions or for fast-motion photography. The only dilemma when using higher ISO measurements is that you may receive digital noise (grain). By keeping the ISO as low as possible, you will obtain the best image quality. The ISO can range from 100 to an amazing 16000.

Reciprocal exposures: ISO 100

F-stop:	2.8	4.0	5.6	8	11	16	22
Shutter speed:	1/4000	1/2000	1/1000	1/500	1/250	1/125	1/60

Digital Noise

A digital sensor is made up of a number of photodiodes. Each creates an electrical signal, which is then processed into a digital image. Interference between the diodes causes the appearance of noise in the image, resulting in a loss of quality. Digital cameras have difficulty collecting information in dark zones, resulting in blotches of color or *noise*. Noise is also obvious on images taken with shutter speeds of 1 second or more. There are solutions to reducing noise. A larger image sensor means that you are able to use a high ISO speed without unduly worrying about noise. This means that you can take pictures in low-light situations without your pictures being underexposed. It also means that in situations where it is required, you are able to use a fast enough shutter speed to prevent camera shake. Noise takes different forms and is usually most clearly visible in areas of even color, such as a blue sky or a night scene.

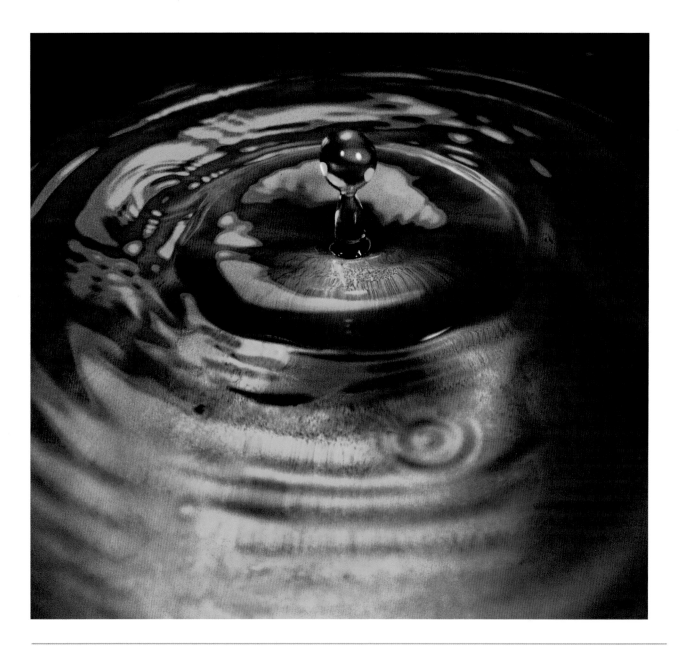

How to Reduce Digital Noise

- Use your histogram to compensate for noise by exposing to the right by adjusting the exposure setting. You may have to do this with a manual setup.
- Select a low ISO setting.
- Bracket your exposures.
- Use the noise reduction feature on a 400 or higher ISO setting.
- Use the camera's noise reduce filter. Set it to ON and switch to your Night Vision. Turn your dial to SCENE and select the correct icon for night shots. There is also a noise-reduction button on your DSLR camera to tackle this problem.
- If you can, shoot in RAW or TIFF instead of JPEG. The latter does not have the same necessary memory (or fewer pixels) and will pixelate or become grainier when enlarged.
- Low light will also increase digital grain, so use a flash or other added light.
- Take advantage of computer software and plug-ins that can control digital noise.

RAW, TIFF, and JPEG

The three main file formats for digital photographs are RAW, TIFF, and JPEG on nearly all DSLR cameras. Both RAW and TIFF formats do not apply any compression to the photo to save space on a memory card. When your camera saves a digital photo as a RAW or TIFF file, the photo includes all of the information captured by your camera's image sensor. RAW files are just the raw sensor data. It isn't a picture until it is processed further when downloaded into your computer.

JPEG is a far more common file format with the public because its compression format removes some pixels that the compression algorithm deems unimportant, thereby saving storage space. As a result, although you can take hundreds to thousands of images, the quality of the image is sacrificed once the image is enlarged more than a postcard size.

Photographers shoot in RAW who prefer to edit their images in postproduction work. RAW is closest to film-quality, requiring a lot of storage space. For example, you could shoot more than 200 JPEG images on your memory card but the equivalent in RAW would be a mere 40 images. Not only does RAW take up a lot of memory space, it also consumes a lot of time to download your images onto your computer.

TIFF is a compression format that does not lose any information about the photo's data either. TIFF files are much larger in data size than JPEG files, hence, they take up even more memory space.

Histogram

A histogram is a chart that looks like a mountain. It is based on a light reading that correlates with the light measurement to a standard 18% gray reference card as a midtone. To read the exposure, you need to look at the left (shadow or black) and right (highlight or white) parts of the chart. A low-contrast scene will hold the entire "mountain" of data well within the left and right borders. The heights of the peaks represent the number of pixels that contain those luminance levels. If a tall peak is in the middle, then your image contains a large amount of medium-bright pixels.

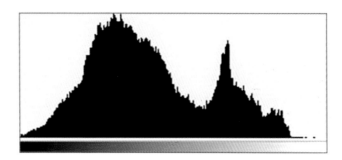

Many digital cameras have a "highlights" function, which indicates areas that are pure white or black, normally by making them blink when the image is reviewed. This enables you to adjust to minimize lost detail resulting from under- or overexposure. A high-contrast scene will use up the entire area of the chart. Underexposure will register as no or little data on the right side of the chart and, often, the mountain at the left side of the chart compared with the right. You want the histogram to slope down as close as possible to the most important brightness values of your photograph. If the highlights are crucial, the slope must end at or before the right side. If the shadows are important, then the slope must favor the left side.

White Balance

Every light source contains different amounts of primary colors (i.e., red, blue, and green); however, we see light simply as white. The white balance tool housed in your camera is used to ensure the colors in your picture look as natural as possible. For example, if you are using fluorescent lighting, the consequences may be an orange tinge to your images. White balance corrects the images to make nearly any light look as natural as possible. Actually, light consists of temperature. White balance, therefore, indicates the variants of temperature. This temperature is a way of measuring the quality of light source. But let's get back to controlling the light. White balance is controlled in three ways: automatic, preset, and custom modes.

Automatic predicts what would make white neutral. This usually works well, but it can sometimes remove the warmth in an attempt to remain neutral.

Preset locks the white balance to reflect the color temperature of the midday sun. It has a tendency to intensify the warmth of a sunrise or sunset and helps capture a warmer artistic effect under artificial lighting.

Custom is designed to store the information of a gray card you focus on in the sunshine. The camera then locks into this setting as standard. This custom white balance information is stored in the metadata that accompanies each image file that is shot with it. Having a mix of cool and warm tones in a shot creates an element of contrast, making the image stronger and bolder.

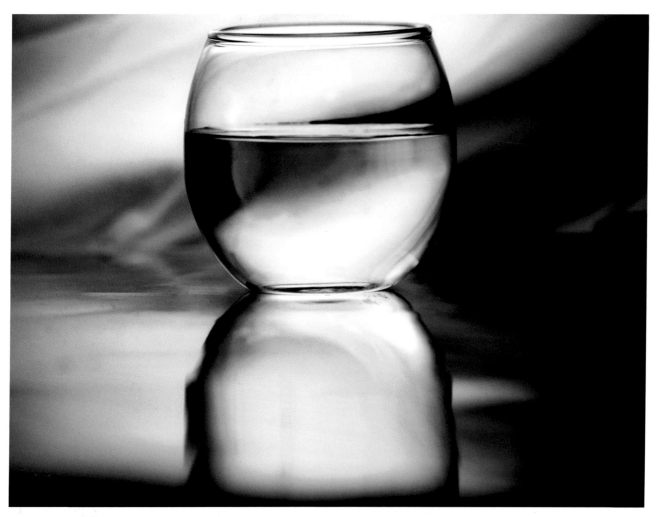

This bowl of water was shot on a silver reflective sheet. I wanted to avoid any warm tones and made sure the white balance played a vital part in neutralizing the image.

Color Temperatures of a Variety of Light Sources

1700K to 1900K	Fire or candle
2800K to 3300K	Incandescent bulb
4000K	White fluorescent or moonlight
5000K	Daylight
5500K	Flash photography
6000K	Overcast sky
7000K to 8000K	Open shade

The other point of interest is the background to use – even for close-up photography – as demonstrated by the shots of the watch below. The first image is using a glossy black background. The second is a silver reflective background. As you can observe, black, oak wood or parchment paper would be ideal for a sophisticated leather-band watch, whereas the silver backdrop is less so. On the other hand, the silver surface would enhance the appeal of a silver metal-band watch. These reflective sheets are easy to obtain at any art supply store.

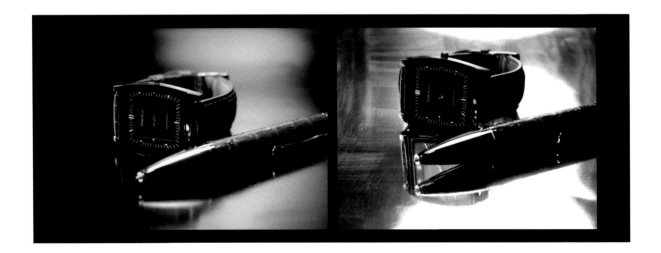

Chapter 3: Flower Photography

Fun or Serious?

Why are you photographing flowers? It seems like such a silly question. The obvious answer is for their natural beauty: a tapestry of colors, textures, and forms. Because flowers will never appear the same on any two occasions, the camera provides us with a means of immortalizing their fleeting beauty. In fact, flowers constitute the second most popular topic to photograph, after people. Yet the question remains: Why are you photographing flowers? Let me put it another way: What do you intend to do with your floral images?

There are several options for floral photography:

1. To enlarge as posters, prints, greeting cards, or calendars
2. For documenting purposes
3. To write an article about certain flowers, garden, or floral event
4. For stock images to be distributed and used professionally

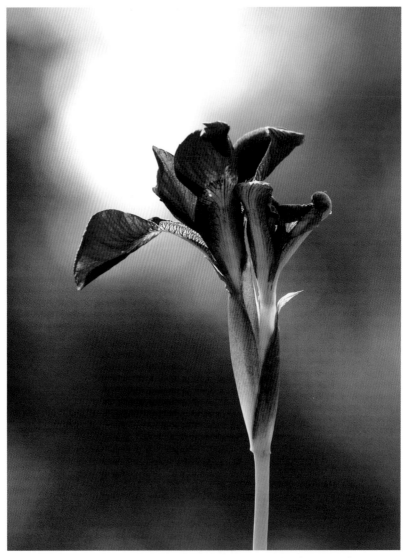

I wanted to make sure that this Iris Hybridia was the center of attention—both literally and figuratively.

I watch my father sweat and toil to make his garden a place of bountiful wonder, but nature has a cruel and uncanny way of often ruining his hard work. To me, gardening appears as a masochistic and expensive obsession, yet if it weren't for people like my dad, I would be deprived of the dazzling brilliance, the multitude of colors, and the opulence of floral variety. A garden is a place of discovery, and the natural elements have an infinite effect in my exploration: the time of year, time of day, the sun, the clouds, the rain, the fog, and the wind all influence the plants and flowers, which themselves are ever-changing.

People assume, quite erroneously, that flowers are easy to photograph. First, although fixed to a spot, flowers are constantly battling the wind, so getting a shot without blur is a battle. Second, flowers are ephemeral, and timing is critical in getting that spectacular shot. Third, it is important to keep your shots as uncluttered as possible—use the simple adage: less is more. Concentrate on observing simple lines, shapes, and colors. A constant problem that I have seen is when a photographer tries to show too much in a picture. Just show what is most important without the distractions. If you don't follow this rule, your viewer doesn't know what to focus on; therefore, the image has failed to capture the right emotion from your audience.

Photography Is All About Observing

Here are two shots of the same Electon shrub roses. Why is the first photograph considered poorly composed? First of all, the ground isn't very interesting, nor does it complement the subject matter. Second, I haven't given the flowers enough individual strength. And third, there are too many irrelevant distractions around the main focus. Try getting down at eye level or shoot upward from ground level as in the second photograph. Notice how the color resonates with the blue sky as the backdrop instead of the ground. It is also a more pleasing image because you can actually feel the rose's dominance.

A photograph of a flower is meant to heighten our awareness of its grace, characteristics, and intimate beauty. Think in forms of color, line, shape, and texture. There is an important distinction between what is beautiful and what is photogenic. The reverse is also true. A dying leaf or a dewdrop may not seem compelling, yet the same leaf can offer a distinctly evocative image. Many flower pictures are mundane mainly because of two factors: poor exposure and unfortunate choice of composition.

Composition is the unifying aspect behind all visual art. If someone told you to photograph a flower differently, what would you do? Think of it this way. You have an opportunity to photograph the portrait of the film director of *Avatar* and *Titanic,* James Cameron. How would you photograph him? Personally, I wouldn't want to just take a mug shot of him, but rather I'd incorporate something about either his profession or his personality.

For example, shoot a ground-up shot of him in a dry dock underneath a massive ship or a direct shot of him emerging from a steamy jungle. The same principle should apply to every shot you take. The same principal can apply to flowers. Bring out the flower's personality, its persona by using correct composition. You may have something important to say, and photography is a wonderful medium to express it. It is how you express it that can change the viewer's opinion on the subject.

Try this as an experiment. Buy a flower, and take it home. Now photograph it as the "James Cameron" flower. With the same flower, now photograph it as the "Tim Burton" flower. Finally, photograph it as the "George Lucas" flower.

The Anatomy of a Flower

There is nothing more frustrating than returning home only to be clueless as to the name of the subject you photographed. It is therefore always advisable to equip yourself with a pen and pad to write down the name (if feasible) of the type of flower you are photographing. If need be, bring a flower guidebook to help with the identification. The image to the right is there to help illustrate the various anatomical sections of a flower.

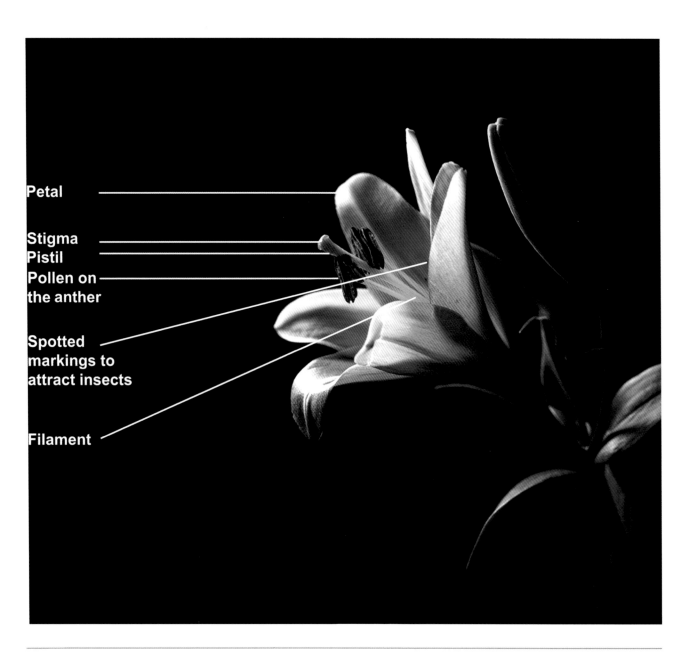

Petal

Stigma
Pistil
Pollen on
the anther

Spotted
markings to
attract insects

Filament

Focus on What You Want to Shoot

When you shoot with macro, focus is vital, and this is where problems reign. Your plane of focus is very shallow, just a fraction of an inch. So you have to make another decision: Exactly what part of the flower do you want to be in sharp detail? The pistil? The stamen? The stigma? Fine-haired cilia? Or spiraling petals? A small aperture improves sharpness, but there are inherent problems: either a very slow shutter speed must be used (not a practical solution outdoors where even the slightest movement of a flower would ruin the shot), or very bright sunlight or supplementary light must be available.

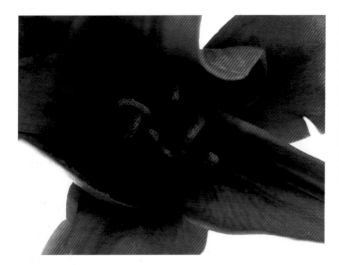 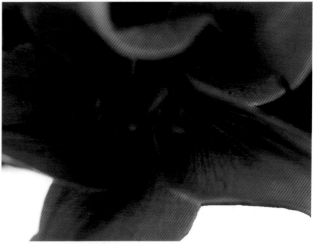

Be careful as to what you are focusing on. The images shown here illustrate a common error. In the photographs opposite, in the first photograph, the focus is on the pistils of this lily. In the second photograph, the focus is on the petals. If you are having difficulty trying to capture the whole flower, dial your camera to Aperture mode and focus using that format. The camera will set the exposure while you worry about a sharp focus. This shot would have been better had the whole flower been in focus.

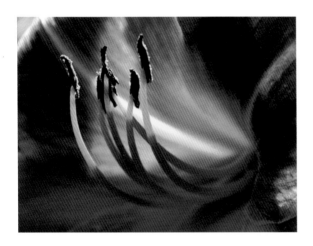

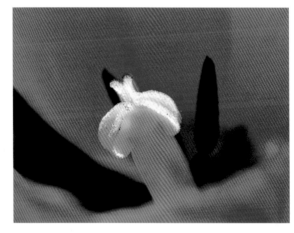

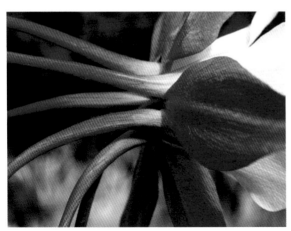

If I'm Shooting Close-Ups, Why Is the Background So Important?

Backgrounds are virtually as important as the subjects themselves in making a picture work, but they are often the most overlooked aspect of photography. If the background isn't a key component to the subject matter, blur it out by using a wider aperture or stronger lens. What you don't want is the background to vie for the viewer's attention; rather, it should complement the main focus as an integral part of it.

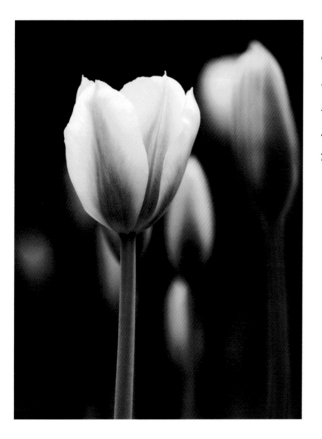

Using a flower that is the same color as the backdrop sounds like a contradiction, but the muted hue actually softens the whole picture while it enhances the foreground.

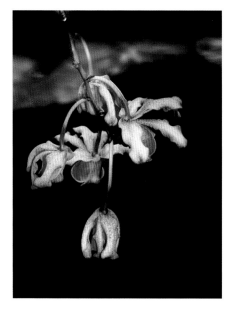

Try to find a strong solid background that will aid in the high-lighting of the fore-ground, preferably dark hues for light-colored flowers and the opposite for dark flowers.

For white on white, make sure the background is overexposed; otherwise the flower will simply bleed into the background. For indoor shots, light the background separately from the flower.

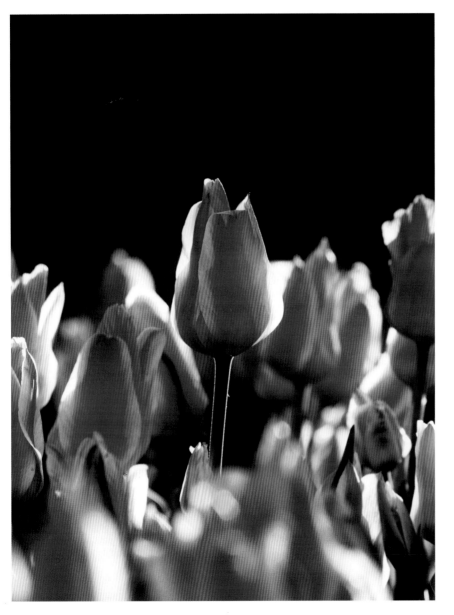

An alternative is to use a backlit angle. Highlight your focused subject to give it a certain independence yet retain a feeling of solidarity. It is particularly eye-catching if the foreground and background are blurred out.

Eliminating Distractions

By using a white board outdoors, you can achieve two goals:

- To reduce any wind.
- To eradicate background distractions.

You can create more aesthetically pleasing images with the assistance of a white or black board. The only difficulty is holding the board behind your subject while looking through the viewfinder, focusing, and pressing the shutter release simultaneously, but it can be done. You may need a stand to hold the board in place. You may think, I can get rid of the background through postproduction on your computer, but it is so much easier and less time consuming to just use a white or black board.

The figure in the left was taken under normal circumstances with an emphasis on the flower in its environment. I then placed a white board behind the flowers for a shot that concentrated on the delicacy of the flowers without any distractions, seen in the figure on the right. An alternative to a white or black board is to try various colored boards as demonstrated by the figures overleaf, including a reflective silver board (last figure), although I must admit, it's a bit distracting.

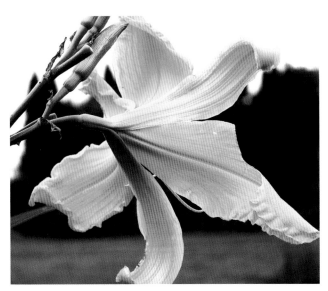
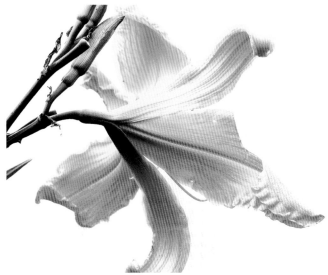

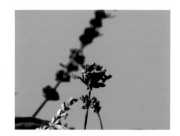

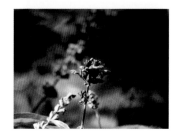

Positive and Negative Space

Negative space, by definition, is the empty space around the subject. When composing a shot, observe how you frame your subject in relation to the positive space and the negative space. The frame is the binding size of the picture, the positive space is the subject, and the negative space is the empty space around the subject. It all has to do with balance and the flow of the eye. If the image is too cluttered, the eye has nowhere to focus.

Negative space acts as a foil or the support to your subject. It is this negative space that is the most crucial aspect in nearly all compositions—having too much or too little negative space can completely ruin a potentially good photograph. Your key decision will be whether you want to preserve the flower in context or focus on the flower in isolation. Green leaves can make a distinct and harmonious background to many flowers, but they need to be sufficiently blurred so as not to detract from the flower itself.

1. The color of the negative space should complement the primary subject. If the subject is light in color, the negative space should be dark and the reverse if the subject matter is dark. A single color is safer for negative space than an assortment of tones that can become too distracting. The exception is soft pastels that blur seamlessly into the background.

2. The negative space's light should be equally intense with the positive space or high in contrast.

3. Unless the background is crucial, try to bleed it out so that the emphasis is on the main subject (i.e., the positive space).

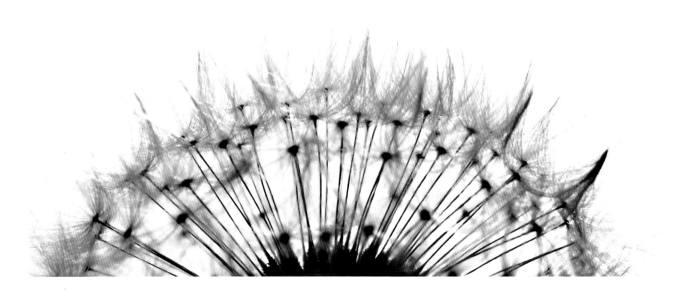

Using Negative Space

Tonal Contrast

The challenge occurs when similar flowers are massed together, offering no contrast. For example, a white flower will stand out better against dark green foliage or a yellow flower against a blue, cloudless sky. You will have to look for ways to get around this in your composition, such as by using a ground-up shot instead of a head-on shot. If this isn't possible, use a longer lens (less depth of field) to bleed out the background.

Sharpness

There are several approaches to sharpness:

- Have your subject stand out as the central focal point. This is a poetic way of representing your subject, by having it in stark vividness while the background is softly blurred. This method is especially effective if the background flowers are the same as your subject flower. Use the widest aperture or f/stop on your lens (i.e., choose something like f/2.8, f/4, or f/5.6, which will give you a very high shutter speed).

- Remember that depth of field is very limited when you are up close. Sometimes you have to shoot at f/16 or so in order to get any depth of field.

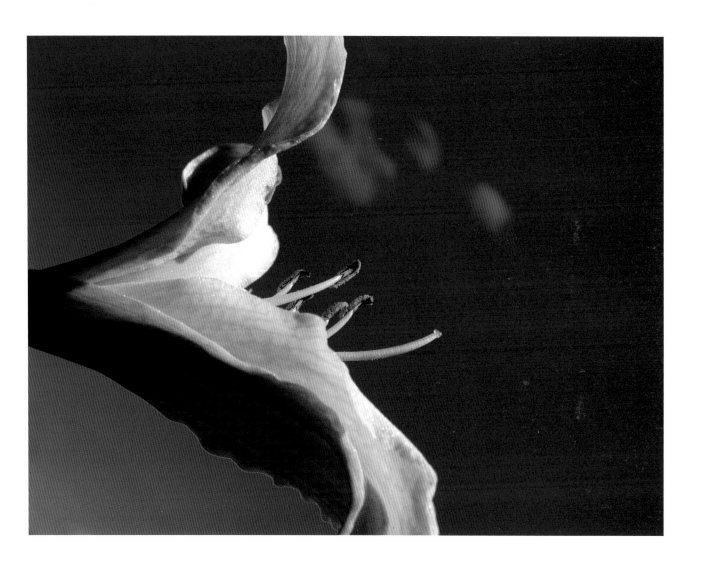

Horizontal versus Vertical

The majority of photographs taken with SLR cameras are in landscape format. People look at the world in a horizontal, 180-degree angle; therefore, landscape format is simpler and almost automatic. It is also time consuming to adjust your camera vertically, especially on a tripod. Nevertheless, try looking at a subject from both a horizontal and a vertical perspective. To use an example, the images of peonies below illustrate two completely different appearances simply by using a horizontal and vertical format. Choose the angle that gives the image the most impact, both aesthetically and descriptively. Bring a small cutout rectangular piece of cardboard with you on your next photo expedition and look through it from both horizontal and vertical viewpoints. It saves a lot of time and energy deciding.

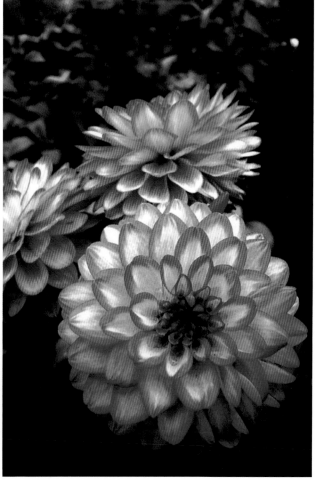

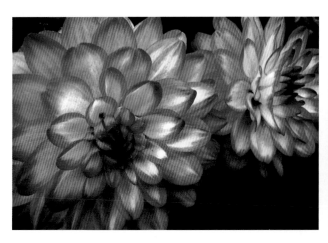

I chose a vertical format for this tulip to heighten the viewer's awareness of the flower's long and sinewy features. The landscape format indicates broadness and a state of collectivism, whereas a vertical shot gives the psychological effect of elegance and individualism.

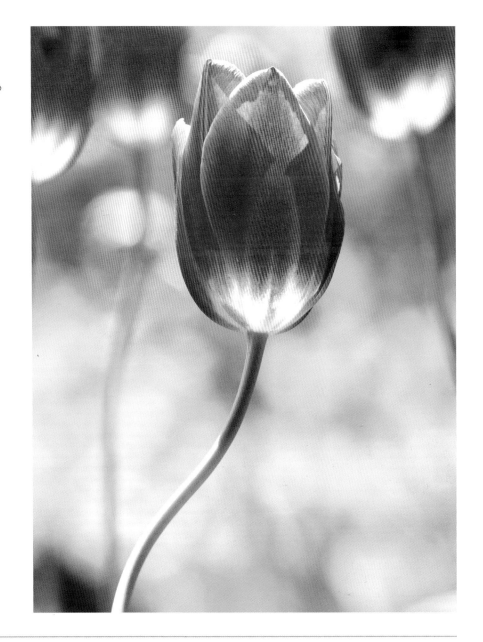

Lines, Shapes, and Patterns

One of the pleasures of taking close-ups is to recognize the elaborate floral patterns. Just as you can use strong lines to direct a viewer's eye toward a point of interest, you can maintain a constant fluidity within the frame that gives the image a sense of vitality or sensuality. To ensure harmony to your picture, try to find a rhythm and balance through patterns and repetitive lines. Such repetitions attract our instinctive attention and can be a powerful ingredient, turning an everyday object into something quite scintillating.

One way to gravitate a viewer into your image is through the use of leading lines. These are patterns or elements that come from the edge of the frame and then lead into the image toward the main subject. The same principle can be applied to circular patterns. It is a fundamental basis of composition—lines generate a sense of movement and keep the flow of the viewer's eye fluid. Geometric patterns can look especially dynamic in black and white. By excluding color from the picture, you can reinforce the interplay between tones and repetitive lines. Some of the best and most striking photographs of surface texture are simple black and white close-ups, which are appealing because of their graphic simplicity. Make sure that the light accentuates any pattern.

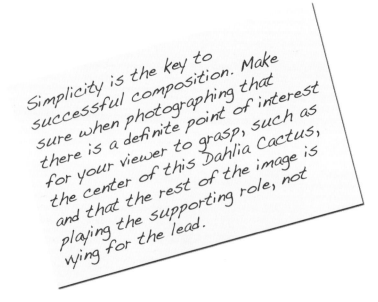

Simplicity is the key to successful composition. Make sure when photographing that there is a definite point of interest for your viewer to grasp, such as the center of this Dahlia Cactus, and that the rest of the image is playing the supporting role, not vying for the lead.

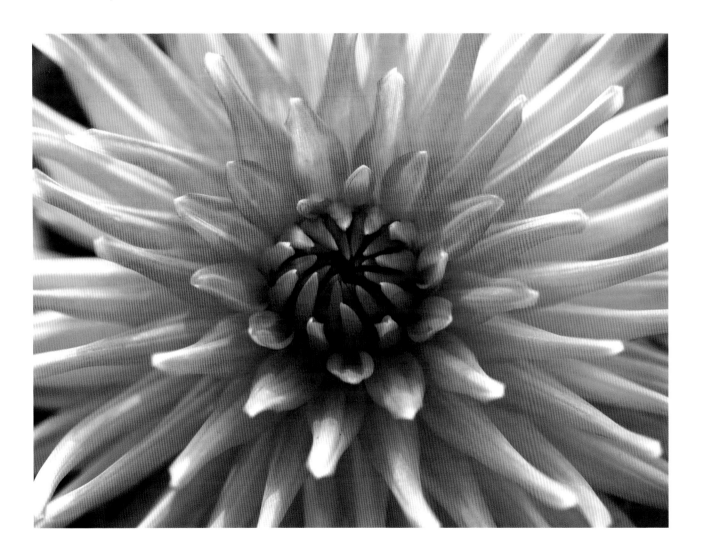

Lighting

Just walk around the flower and discover how front lighting displays the flower but loses the texture; see how the petals become delicate and transparent with back lighting or as an interesting silhouette. Side lighting reveals more of a three-dimensional feel than front lighting. And diffused lighting allows for the minimum of contrast and glare. To be able to "see" light and to comprehend how it translates into a final image is the most powerful tool at your disposal.

However, contrary to popular belief, a beautiful day doesn't entitle one to beautiful shots. If anything, a photographer is faced with a difficult quandary: the dichotomy between deep shade and bright glare. Nevertheless, strong daylight also has some distinct advantages. It allows the photographer to use small apertures (i.e., f/8 to f/22) for a greater range of depth of field, to utilize faster shutter speeds (i.e., 1/125 or greater) to capture anything in motion, and to take pictures using lower ISO ratings to maximize image quality.

When confronted with extreme light conditions, it is not possible to expose adequately for both the bright and shadow portions of the composition because there is a difference of three or more f-stops between them. The shadows can be imaginatively utilized as part of the composition, either to create a dark background or to emphasize the structure or texture of the subject. Bright spots, glare, or haze from harsh lighting tend to draw the eye away from the focal point of the photograph. One way to minimize this distraction is to limit the depth of field. By using a wide-open aperture, such as f/1.4, f/2, or f/2.8, the bright areas will seem to fade out, losing their definition. (There is more information about lighting in Chapter 4.)

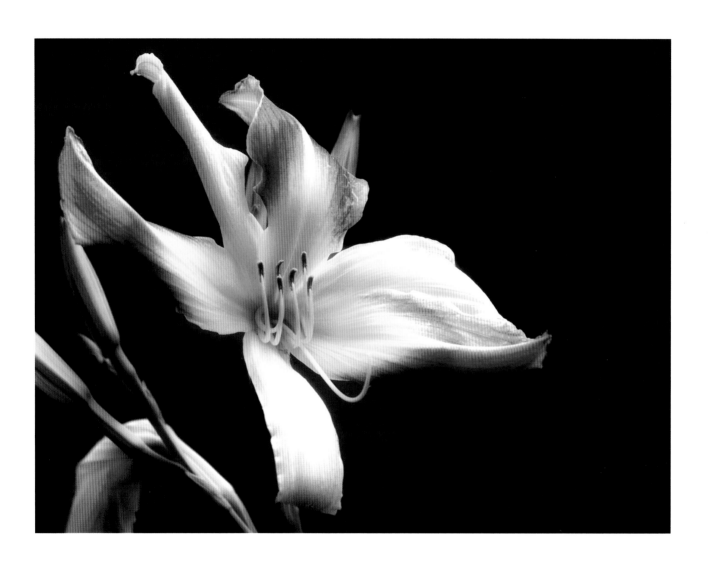

Color

What makes color so fascinating is that it can manufacture a mood or visual tension. Of course, our perceptions of color are subjective, but there is a universal generalization as to what certain colors represent. Red may be a warm color, but it can also provoke emotions of warning, anger, and rebellion. On the other hand, orange and yellow are also warm colors and emit a feeling of happiness. Blue, green, and purple are cool colors, usually associated with calmness, but they can also suggest a sense of sadness or indifference.

A red flower is the result of the red pigments in the flower absorbing blue and green wavelengths while reflecting red ones. A white flower reflects all colors equally. To punch up vivid colors, make sure the background is dark or green, then underexpose by two thirds to make the foreground pop. Alternatively, set your built-in color saturation dial to a higher number and bracket your shots for the best possible result.

Photographing Multicolored Flowers

Very colorful flowers are better photographed in soft, diffused lighting such as on a hazy or overcast day or in open shade on a sunny day. Direct sunlight can create too many bright highlights or impenetrable shadows. Like with white flowers, you will need to underexpose your shots.

Say more with color. Dynamic, vibrant hues can be spellbinding and may actually be more powerful than the subject matter, generating a completely different impression of the object. Don't forget, most of photography is about inducing an emotional response.

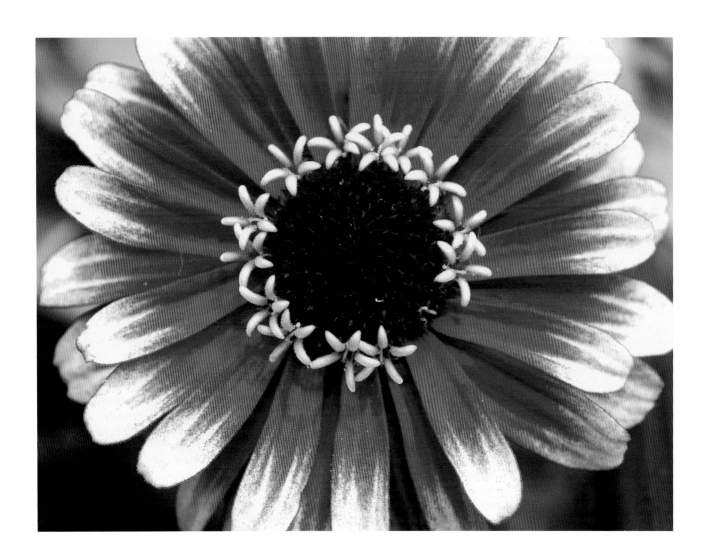

Photographing Roses

When it comes to capturing the essence of roses, keep your shots as simple and as clean as possible. Get as close as possible to highlight the intricacies and delicacies of each petal. Any angle can result in something truly beautiful, even underneath, as seen in the ground-up shot behind the shrub rose (Figure 4), but don't allow the background to disrupt the main focus. It is the rose that is important, so use a long lens, a small aperture, or a white board as a background, or stay with a macro lens. Although it is preferable to shoot roses on overcast days in order to obtain as much detail as possible, still use a reflector and always use a tripod.

fig. 1.
Shrub Rose taken with a 35mm macro lens and a reflector.

fig. 2.
Shrub Rose taken in a studio environment with a macro lens and several lights.

fig. 3.
Throughout the centuries, roses are regarded as romantic flowers, so it doesn't hurt to give them a softness to accentuate the impression of intimacy. I used a soft focus filter when shooting this bouquet.

fig. 4.
Unless you're going for an aesthetic shot, try to avoid the standard approach of standing overhead and shooting into the heart of the flower. Try underneath, angled shots or from behind the flower.

fig. 5.
I shot these roses in the studio and lit them from both below and above for a direct mail piece. The circular art direction produces a nice frame for any text.

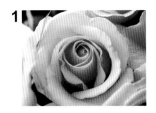
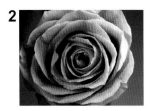
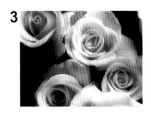

Photographing Red and Yellow Flowers

Red spells passion, power, and sex appeal, but red flowers are also some of the hardest flowers to capture because they absorb light, diffusing detail into a blur. To compensate, compose your shot, then take a meter reading of a gray card placed beside the flower. Be sure that the card fills the whole frame, then meter the light reflected off it. Use a gray card when lighting situations can perplex the camera's light meter. If you get a similar reading with the card as without, you don't need the gray card. Nevertheless, for reassurance, you should generally use the gray card recommendation.

Photographing Blue and Green Flowers

Blue is the color of celestial calmness. The problem with acquiring the true blue in blue flowers is their penchant to reflect red and infrared wavelengths that humans don't see but the camera records. To offset this anomaly, wait for a cloud to cover the sun when photographing blue flowers or use a diffuser to produce a colder light. Also, photograph the flowers shortly after they have opened, as the shift to the pink or mauve part of the spectrum intensifies with the age of the flower.

Photographing White Flowers

The color white represents purity; however, white and cream flowers are among the most difficult to photograph because they are irrefutably more sensitive to light. Getting the correct exposure using a reflected in-camera reading can be tricky. In most cases, it is recommended to underexpose what you read in your meter. Bracket your shots accordingly. White flowers are also great for black-and-white photographs. The original objective, photographing the flower's color, is usurped by the flower's more distinct features: shape, form, and shadows.

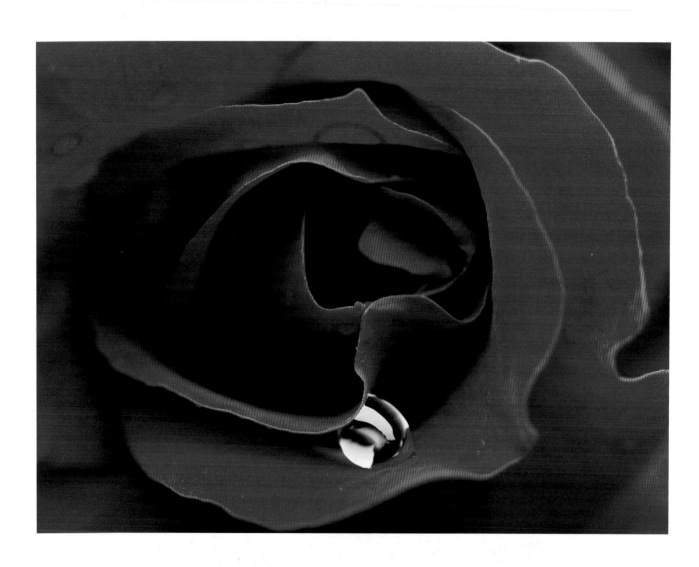

Photographing Flowers in Black and White

Photographing flowers in black and white may seem counterproductive, but it is actually very rewarding. A good black-and-white image stands the test of time. It appears "timeless." Black and white focuses the attention on form, shading, pattern, and simplicity. Many photographers prefer using black and white because it enforces the viewer to see the world in a way that cannot be seen by the naked eye. There is a psychological element that plays on people's perception. Be aware that red flowers can reproduce as gray and dissolve into a green background. If you want a red flower to stand out, use a red filter. Use a green filter for a dark flower against a light background.

Lighting is a necessity for a good black-and-white photograph because it affects all of the previously discussed elements: shape, contrast, pattern, and texture. Be alert to avoid glare; it is so common to find splotches of white on petals from the sun's harsh rays. Side lighting often produces the most dramatic black and white photos. It picks out the edges of shapes and increases contrast by adding highlights, and the shadows it creates add interest to the scene as well as enhancing textures and patterns.

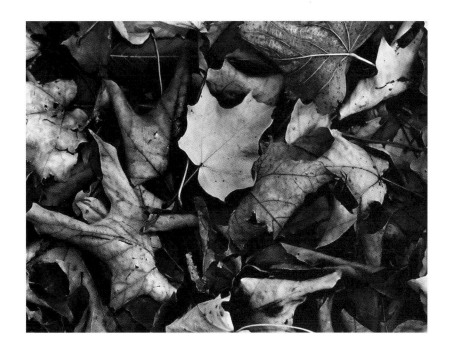

Black and white is not only effective for flowers; it's a powerful medium for still life too. Virtually anything can look dramatic in black and white from rusty nuts and bolts to cutlery and kitchenware. Strong lighting is paramount in defining shapes and emphasizing texture.

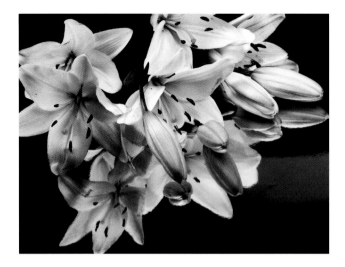

Sepia

The wonderful aspect of using sepia is how it conveys an aged but intimate appearance to your print. The result isn't as harsh as stark black and white. Many digital cameras produce "sepia-toning," or you can adjust the coloring in post-production. Change your grayscale image to the CMYK color mode (if you want your image professionally printed, otherwise, convert to RGB). Once in RGB, desaturate the image. Use the Levels command to make the image lighter and grayer, and then remove the blacks and whites. Add color by manipulating the Color Balance or use the Variations command to add red, yellow, or blue to produce the brown or tinted effect.

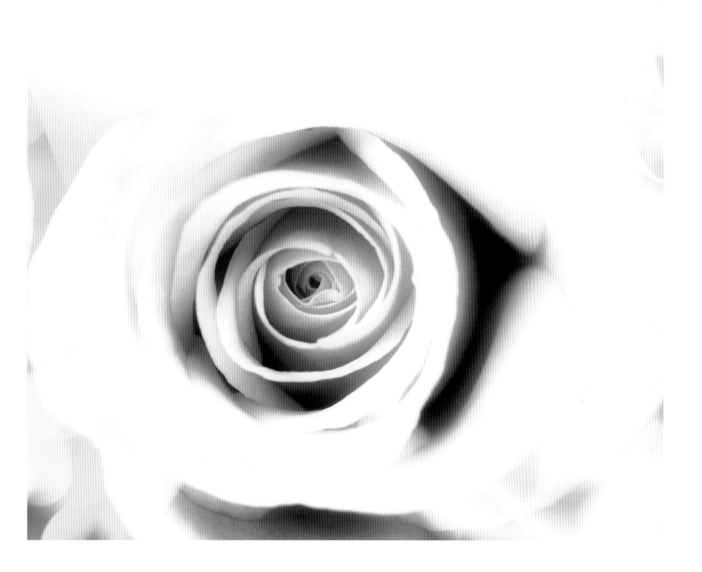

Leaves

One thing about leaves is their abundance. You can virtually walk anywhere and you will find a leaf. Never underestimate the attractiveness of the simple leaf. There are a variety of reasons for photographing leaves:

- They offer a variety of colors, particularly during autumn.

- Capture their translucence in the sun with back-lit photography.

- Use your macro lens to focus on their veins, highways of irresistible patterns. A dying, dried leaf can develop intricate and convoluted shapes. Good for close-ups as a studio shot.

- Leaves also make great black and white images.

 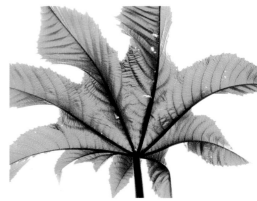

Weather

There really isn't a bad time to photograph flowers. In winter, capture a dead leaf imprisoned by ice or frost. Often after a rainstorm the aftermath becomes one of celestial light. Or seize a raindrop clinging precariously to a leaf, petal, or pine needle. In fact, it is often recommended to photograph flowers during bright, overcast days. The thin film of cloud acts as a diffuser and softens the sunlight coming through it, allowing better detail to be captured. It also reduces shadows. This light is particularly beneficial for white or light-colored flowers because their delicate hues won't be burned out.

> There is a tendency to accentuate blue tones when photographing in winter or in the extreme cold. To compensate, use a warm filter, such as an 81C, or photograph in RAW and fix the tone in postproduction.

Rain

Do not despair if it rains; it is fortuitous. There is a wonderful crispness in the air after a rainstorm, and it is the perfect time to capture raindrops perched precariously on twigs, branches, flowers, and spider webs. Raindrops or dewdrops offer interesting reflections while the dramatic skies make for excellent backgrounds. Use fill-in flash to add vibrancy to the foreground, and bring a plastic bag for your camera's protection. A foggy day is even better, as it cloaks the background in a soft mist.

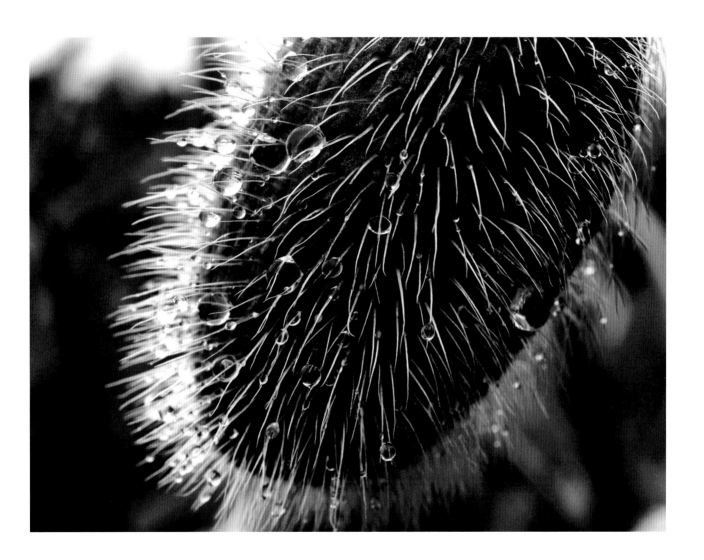

Lens Hood

More often than not, you will probably be photographing on a sunny day. Now this sounds absurdly obvious, but an essential accessory is the lens hood to avoid flare from intense light falling directly onto your camera's lens. If you don't have a lens hood, use the protection of your hand, a board, or a reflector to shield the sun from your lens. A lens hood also protects the lens of your camera from bumps and scrapes.

PHOTOGRAPHING INTO THE SUN

Make sure it is a close-up of the flower, otherwise:

- Photograph from under shade.
- Use a lens hood, filter, or an object to shield from the glare.
- Use fill-in flash.
- Use a reflector.
- Change your perspective.
- Play with the white balance.
- Shoot silhouettes.

Other things to consider bringing on a shoot are the following:

- A hat (maybe a pair of waterproof boots).
- Wear old clothes, like jeans, that can get dirty.
- A pad and pencil (for writing down the names of flowers for accuracy.)
- Extra batteries and memory disks.
- A towel to kneel on.
- And always check the night before that your battery isn't low or dead.

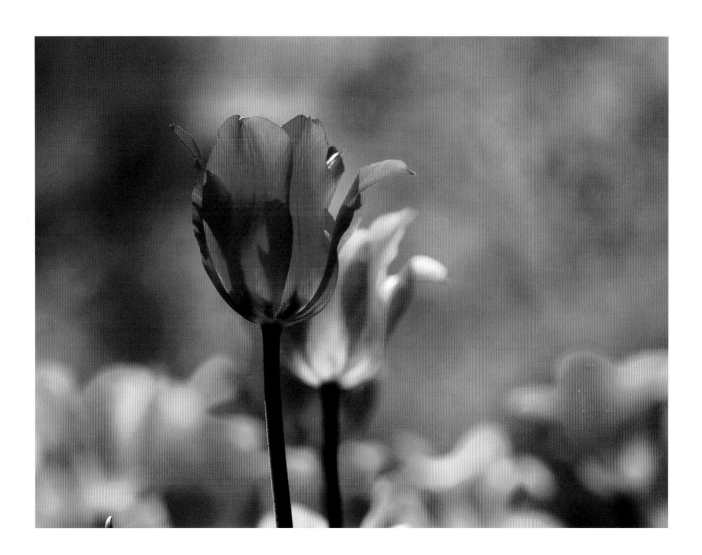

Filters

Filters are useful for intensifying, softening, or avoiding further perils presented by the weather. There is every conceivable filter designed to project the desired effect from rainbows to artificial motion, but the most practical filter is the polarizing filter, which helps prevent flare. A polarizing filter can dramatize landscapes, garden vistas, and compositions with sky, water, or reflective greenery. The effect is to deepen and brighten colors that may be washed out by reflective highlights. Be aware, whenever using a filter, that light intensity is generally reduced by about 1/2 f-stops, so it is best to bracket your shots. A neutral density filter is ideal for outdoors to neutralize bright days with a lot of glare. The filter reduces or modifies the intensity of all colors of light equally without rendering or alternating the original hues. Here are some samples of filters I used to photograph a day lily in my studio.

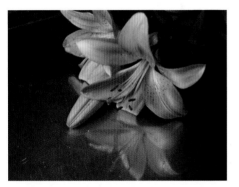

The original, drab shot

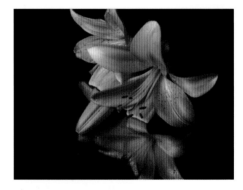

2+3 sepia filter

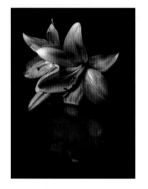

warming filter 85A

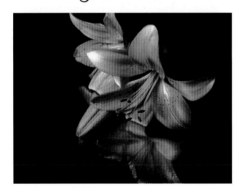

Grad. flow M2 filter

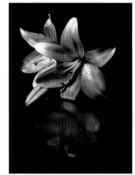

Polar blue-yellow A73 filter

Aesthetics

Of course, sharpness is not a virtue when aesthetics is your aim. Some of the most beautiful images have limited sharpness and focus or are deliberately subdued for the effect of intimacy, delicacy, and an ethereal nuance. Photographer Sarah Moon was famous for her hushed, pastel-induced fashion photography that was, during the 1970s, a radical departure from the norm because it introduced something that was romantically nostalgic. Some floral photographers of note are Robert Maplethorpe for his seductive black-and-white floral shots, Jonathan Singer, Magda Indigo, Freeman Patterson, Dawn LeBlanc, and Brian Auer.

Photography should be about experimentation, so test your ability with filters and gels, use cheesecloth or Indian cotton, and set your subject against the afternoon sun. Try double-exposure, shaking the camera, panning, long time exposures, and, of course, Photoshop or any edition of software you like.

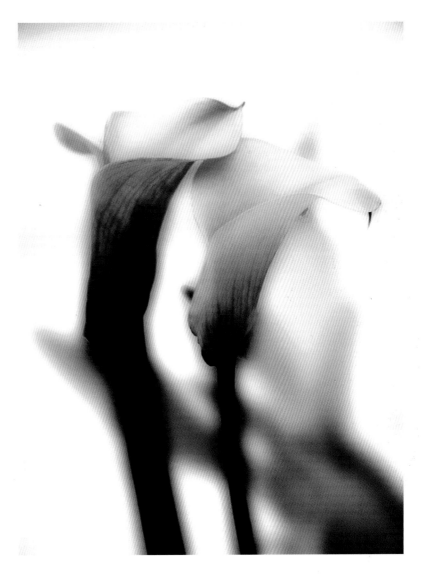

VINHO REGIONAL LISBOA

Berço do Infante

RESERVA 2008

VINHO TINTO RED WINE

Chapter 4: Lighting

Although lighting is everything, it is the intensity of the light that is the determining factor. Light can enhance a subject from an ordinary shot to something quite extraordinary. The same subject can display a completely different aura in different lighting situations. Take the wine bottle shown in this chapter-opening photograph. Direct light would make this bottle bland and featureless, side lighting is mysterious, because half the bottle dissolves into darkness, backlighting just leaves a silhouette, but if you can arrange the lighting (more than one light), you can get the "classic" look of elegance articulating the sophistication of the brand without having to reveal too much.

Outdoor Lighting

However, contrary to popular belief and as noted earlier, a beautiful day doesn't entitle one to beautiful shots. If anything, a photographer is faced with a difficult quandary: the dichotomy between deep shade and bright glare. Nevertheless, strong daylight also has some distinct advantages. It allows the photographer to use small apertures (i.e., f/8 to f/22) for a greater range of depth of field, to utilize faster shutter speeds (i.e., 1/125 or greater) to capture anything in motion, and to take pictures using lower ISO ratings to maximize image quality.

When confronted with extreme light conditions, it is not possible to expose adequately for both the bright and shadow portions of the composition because there is a difference of three or more f-stops between them. The shadows can be imaginatively utilized as part of the composition, either to create a dark background or to emphasize the structure or texture of the subject. Bright spots within the shadow area, or beyond it, tend to draw the eye away from the focal point of the photograph. One way to minimize this distraction is to limit the depth of field. By using a wide-open aperture, such as f/1.4, f/2, or f/2.8, the bright areas will seem to fade out, losing their definition.

Front Lighting

Be forewarned, front lighting is like light on steroids. It can cast blinding light from overhead and can overwhelm your subjects with high-contrasting light: deep shadows and glaring white highlights. This is not the lighting for portraits, and it can make floral photography difficult because it has a tendency to produce bland, unattractive, documentary-style lighting that comes across more like a mug shot than a portrait or it can pit the subject with white burnouts. It is also notorious for lighting up both the foreground and the background. On the other hand, direct lighting (usually during the midday sun), seizes color saturation, presenting colors in their bright and vibrant splendor, although texture may be sacrificed.

Here are the ways to combat direct or front lighting:

1. Reduce the high contrast with diffusers and reflectors (however, this will only lower your shadow contrast).

2. To concentrate the light on the foreground rather than the background, limit the depth of field by using a wide open aperture, such as f/2.8 to f/5.6, to fade out the background.

3. Underexpose the foreground to darken the background while retaining the foreground's texture. This can be accomplished by changing your exposure, increasing your ISO, or adjusting your bracket shots using EV settings.

4. Use a gray card. When you need accurate exposure, place the gray card beside the subject matter (unless it is an insect) and take a reading using the camera's meter in Manual mode. If the camera doesn't offer this option, use the AE lock, note the exposure, and set it to Manual mode.

5. Expose the image by checking your camera's histogram on the LCD monitor.

6. Shoot using the RAW file format, and adjust the exposure in postproduction.

7. Use a polarizing filter.

8. Because the light is behind you, make sure not to get your shadow in the frame.

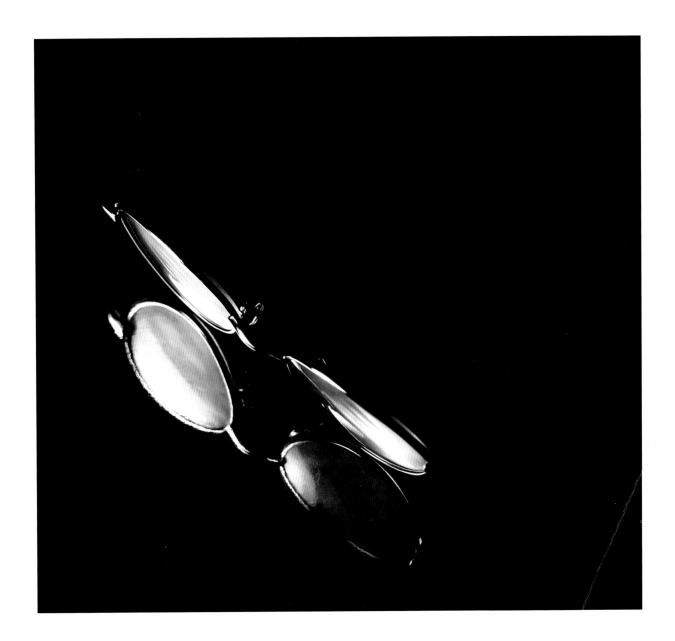

Back Lighting

A flower may look uninteresting with the sunlight directly above it, but it can suddenly be engrossing once the light is behind it. To exemplify an ethereal effect by capturing the celestial translucence, position yourself in front of the flower with the sun behind it. This is a great opportunity to capture light filtering through the diaphanous skin of petals; highlight pines, dewdrops, or the iridescent glow of hairs; or emphasize the veins of a leaf. Ultimately, this effect works best on delicate flowers like poppies, buttercups, and tulips. Keep the background darker than your subject and take the meter reading from the shaded side of your subject for a more precise exposure, otherwise it will end up being a silhouette (unless that is your intention).

Be careful of light streaming into your lens, as this will cause flare. Make sure you use a lens hood or position yourself under shade and use a telephoto lens when shooting into the light. Backlight is the most difficult to measure because you are reading into direct light. Because this is the case, use a spot meter or move as close as possible to the subject. Having done that, overexpose your meter reading by 11/2 f-stops to get proper exposure, which will give you an exact reading of the sky. When framing a backlit subject, make sure you eliminate the source of the light (e.g., sun), so move around the subject until only the effect of the light on the subject is seen.

Silhouettes

For an image that lacks particular detail, silhouettes are an alluring way to convey drama, mystery, and emotion. The background sets the scene while the silhouette emits the mood. Though generally not utilized for close-up photography, there are opportunities to explore.

You can literally take a silhouette shot at any time of the day, under any circumstances (including harsh sunlight or artificial lighting), providing the background is lighter than your subject in the foreground. Many photography experts will recommend that you shoot either at dawn or at dusk for the most dramatic results, such as capturing the crimson hues of a sinking sun in the background, but I personally like shooting into the sun around noon—I can hear the experts gag. This hour is usually when the sun is at its harshest and usually inappropriate for shooting most scenes or objects, but it's fine for taking shots of silhouettes—the contrast is more apparent.

When estimating your exposure, take a reading from the background rather than the foreground. If you take a reading of the foreground, you'll end up with an accurate exposure of the subject and an overexposed background that contravenes the whole purpose. When focusing on the background, just press the shutter halfway down and don't let go, then move your camera back to your subject to finish the shot. Mind you, a maximum depth of field is required, otherwise your foreground won't be in sharp focus.

To avoid detail in your foreground subject, here are a couple of strategies. First, take the exposure reading of the background and adjust before focusing on the foreground. Second, use Aperture mode to maximize your depth of field (i.e., f/22); consequently, you should have a sharper foreground and background. This also means that you may need to use a smaller lens, such as a 50mm down to a wide-angle lens. Third, it is also advisable to bracket your shots to get a variety of rich exposures.

When searching for scenes, choose something that is clearly recognizable and is interesting enough to hold your viewer's attention. This is where you can take an everyday scene and make it intriguing. Silhouettes do not have the advantage of color, textures, or tones, so it is imperative when focusing that the shape is distinct. Normally a silhouette with a striking colored background (sunset, fireplace, etc.) is going to have a very strong contrast; however, the same can be true about black-and-white images as long as the background remains seamless and lighter than the focused subject.

Frame your subject so that the sun (or the harshest part of the background light) is positioned completely behind the focused object. If this isn't correct, you will end up with glare and a disappointing result. Most silhouette shots using the sun as the backlight are taken from a ground-up perspective. Don't be too shy to get down on your knees or even your stomach for the right shot. Framing creates an important aspect in the composition of your photo and helps to escort your viewer's eye to interpret your intention.

Another experiment to try is to tape white bond paper or thick tracing paper on a window. Position a flower (something delicate) in front of the paper by a few inches, or if the flower is light enough, tape it to the paper. After I photographed the silhouette of the flowers, I manipulated the original black to a gradient for more appeal as seen in the figure opposite.

Note that when composing your shot, do not overlap silhouette objects in a way that will make them merge together and confuse the viewer. Remember, they are solid black shapes and need to be defined precisely and separately.

Side Lighting

To emphasize your subject's shape and textural detail, move so that the light hits it from a side angle. You will get more interesting, though uneven, results. Unlike backlighting or direct lighting, the light is reflected from the subject before it reaches the lens. The difficulty comes in the metering that results from the high contrast between light and shade, as you will be dealing with positive and negative (dark background) space.

This is where you need to complement the two together. If the lighting is too extreme, use a reflector on the shaded areas or meter the bright area but drop your aperture down an f-stop or two. Also, experiment with bracketing until you're satisfied with the result. Otherwise, meter the bright highlights, then underexpose sufficiently to saturate the colors. How much you underexpose will depend on the intensity of the light and the contrast of color between the object that you are photographing and the background. The brighter the sidelight and the greater the degree of color saturation desired, the more underexposure you will need.

In this particular shot, I wanted to capture the mood of the Cold War. A conspiratorial age ensconced in the politburo and a weary doctrinarian.

What is so effective about side lighting is that it can be wonderfully evocative.

This image set the mood for a diner's menu. The client wanted something more welcoming with a hint of anticipation. I tried various lighting angles, but the side lighting gave the most interesting appeal.

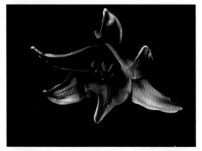

I shot this lily on a black reflective sheet. The subtle reflection resonates a distinct elegance.

This is one of my favorite shots because it is, in my opinion, so sensual. The combination of soft side lighting and a gentle expression enveloped in black and white at 3200 ISO created a timeless moment.

Side-lighting was ideal for this shot because it is capable of emphasizing shadows, enhancing the ripples of skin and toe prints. Had the lighting been directly overhead, it would have bleached out too many details.

Diffused Lighting

Although diffused light lacks the intensity and drama of strong daylight, it offers a softness and uniformity that is especially effective for the subtler aspects of photography, in particular for flower photography. Diffused light has the advantage of minimizing or eliminating shadows and glare. In close-up work, backgrounds blur out easily and pastels retain their integrity. Because the light is so even, pure colors are easily saturated without the need to underexpose them. Note that when you have a pale, emaciated sky, it is advisable to shoot your subjects at close range or directly, avoiding an anemic-looking sky. Also, this lighting condition isn't the most ideal for close-up photography because it requires ample lighting. You will probably require lower shutter speeds and a higher ISO setting.

Despite a decrease in light intensity, a cloudy sky is still much brighter than the land below. Proper exposure for the land portion generally causes the sky to go white, leaving an empty, unattractively overexposed space, so if you do shoot from the ground up, try to eliminate most of the sky in your picture.

I took this shot of tulip stems after a rainstorm for its unusual perspective. Normally, I would have taken a close-up of the raindrops clinging precariously to the petals, but I thought differently this time. The sun was trying to break through the clouds and the sky was about as appealing as a dirty wet towel. I believe the ground-up angle was effective because I managed to achieve an intriguing shot while avoiding any distractions, such as the weak sky.

Studio Lighting

Indoor lighting could amount to anything from a couple of tungsten lamps to an expensive studio setup with strobe lighting and overhead soft boxes, but for tabletop photography, all you need is a table (I use a Meda-light, which is a white plastic tabletop with a curved back), a backdrop (this could be a backdrop roll bought at a camera store to wallpaper or cloth), and available light. The advantages of tabletop close-ups make them hassle-free: there is no wind to contend with, you can shoot anytime of the day, and you can set your lighting to any angle you want. And with a little imagination, it is perfect for experimenting.

But say you are shooting with natural light from a window. There are two types of window light to be concerned about: direct and reflected. Direct sunlight presents the same dilemma as being outdoors in that it can compound the situation with glaring light spots, so it is best to diffuse the light coming through the window by using sheer, cheesecloth, tissue, muslin, or a sheet of plastic to cover the window. Reflected sunlight, which is indirect sunlight, usually provides soft window lighting. With such light, it may be important to use a reflector for fill-in light or shadow control. Do not use the flash embedded in your camera. It is too direct and harsh. Instead, use bounce flash or simply redirect your individual light sources. A tabletop setup can vary from natural light from a window and a reflector to three- or four-light setups. It is often best to shoot small objects with small light sources. Why? If your light source is too large or too close to the subject, the consequences are generally flat and bland. The angle of the camera is also crucial. If you are shooting for catalog work, have your camera plane either to the subject or at a 45-degree angle. For more creative work, almost anything goes including a wide-angle lens.

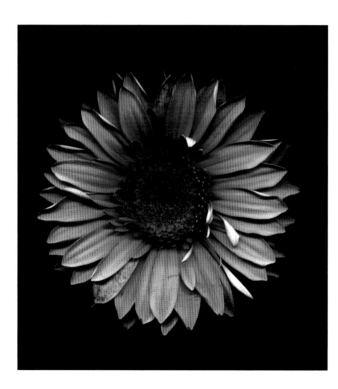

Incandescent Lighting or Continuous Lighting

Tungsten bulbs usually have a lower color temperature and produce a warmer (i.e., orange) glow than the bulbs made for photography. To adjust, set the correct white balance to Tungsten. In addition, shoot in RAW so that you can adjust the white balance in postprocessing. Incandescent lighting is also termed *continuous lighting* because it doesn't work as a quick, burst of flash. It is an inexpensive way to set up your studio lighting for macro photography. The advantage of tungsten lighting is that you can manipulate the light's direction, power, color, and proximity. To reduce the intensity of light, use a diffuser soft cover over your tungsten lamp heads. There are three main categories of continuous lighting: tungsten, halogen, and fluorescent.

Tungsten

This type of continuous lighting tends to be the least expensive. It uses tungsten bulbs (like the ones in your home but usually larger). They are usually inexpensive to replace but have a short life—normally around 15 to 18 hours.

Halogen

This type tends to be more expensive than tungsten but has a longer bulb life—around 200 hours.

Fluorescent

This is the newest type of continuous lighting, and it has the advantages of cooler operating temperature and long bulb life—around 8,000 hours.

> **WARNING**
>
> Continuous lighting can get *very* hot. To avoid a fire, be careful to let your lights cool down after a shoot prior to putting them away.

Strobe Lighting

Strobe lighting is a flash type lighting that is similar to the flash on your camera. All strobe lights have a flash tube that fires only when the camera transmits a signal for it to fire. The speed and intensity is calibrated in watt-seconds, which is a watt times 1 second (varying from 1/50,000 of a second to 1/1,000 of a second). If you are a beginner with strobe lights, try Novatrons whereby you can control the light ratios at the heads, not at the pack. The difference between continuous lighting and strobe lighting is that strobe lighting is far more crisp, intense, and clean.

Monolight Strobe

This lighting is self-contained. Each strobe head has its own power pack. This type of strobe is the most common, as they are easy to transport and tend to be less expensive than the other types.

Power Pack Strobes

These lights have all the strobe heads wired to a central power pack. All the parts are interchangeable, enabling you to alter the power from a 240-watt seconds kit to a 500 by just changing the power pack.

Advantages of Strobe Lighting

- Long life (most strobe tubes last for more than a half million flashes).

- Strobes do not generate heat (they fire only when the camera tells them to).

- True color temperature (most strobes have a 5100K color

temperature, which is daylight quality).

Disadvantages of Strobe Lighting

- Harder to learn to use (when using strobes, you must shoot on the manual setting and the aperture and shutter speed must be set correctly).

- A strobe must be triggered by the camera (all strobes need to have the camera tell them when to fire; many of the newer digital cameras do not have a port to plug into, but this can be overcome by using a PC adaptor that fits on the camera's hot shoe; the other method is to use a wireless transmitter).

Advantages of Continuous Lighting

- Easier to use than strobe lights (you just turn them on, position them where needed, and shoot on the auto setting).

- No connection to a camera is required.

Disadvantages of Continuous Lighting

- Generates heat (especially tungsten and halogen tend to get quite hot; fluorescent is cooler).

- Require white balance (you will need to do a white balance on your camera to correct the color).

- Bulbs need to be replaced more often.*Focus On Close-Up and Macro Photography*

Fluorescent light will appear very green in color to the digital sensor. To compensate for a neutral tone, set the white balance to fluorescent and the camera uses a magenta filter. In difficult circumstances, set the white balance to Auto, shoot in RAW, and compensate the balance in your computer. When mixing strobe with incandescent lighting, use a colored filter over the strobe, such as plus green, to correct the light emitted by the fluorescent tubes. The shot above was a concept I had for the Dublin Film Festival.

Chapter 5: Subjects to Photograph

Automotive Photography

Art doesn't have to hang in a gallery. It can be seen every day prowling the streets. It is through the innovative aesthetics of design that the car has evolved from an amorphous, utilitarian conveyance into a rolling, metallic sculpture. So how do you capture the personality of such machines? And how do you achieve this with close-up photography?

To begin with, most of us do not have the luxury of choosing the desired background to do a car shoot, nor do we have a hangar-sized, fully equipped studio to accommodate such vehicles. It's all very well to have someone say, "Why didn't you shoot the Lamborghini on a wet tarmac to reflect its dynamic lines or position the Shelby Cobra on a stretch of desert highway and shoot it at a high angle with the highway fading off into the horizon? What do you mean, you can't do that?"

In most cases, vintage, custom, or the super exotic cars are often accessible only at various car shows. Outdoor shows can be frustrating because of the vortex of spectators standing around each exhibit. Indoor car shows are equally hindering because of the crowds, the rope barriers, and the harsh lighting that peppers the surface of each vehicle. Nevertheless, the benefit of photographing vintage cars and street rods is that each one has its own unique features. The objective is to express these traits by separating your subject matter from its ilk. It is the ability to find these idiosyncratic features and photograph them to their best advantage that will make your images irreplaceable.

Create your own style or niche. That is where close-up photography comes in.

Ground-Up Shots

Though most photographers seem interested in photographing a vehicle in an establishing shot (a long shot) by finding the right angle, close-up photography can illustrate the essence of the car's distinct character. Explore your options. For example, to present a car with a menacing or intimidating appearance, shoot from ground-up (called a "belly shot"). This angle always empowers the subject. As seen in the image of the 1960 Chevrolet Impala, the ground-up approach enables you to enhance the heaviness of the car, the snarl-like design of the chrome of its era, and simultaneously to avoid any superfluous distractions—like people mulling around the vehicle. In addition, the photo is balanced by equalizing the bulk of the car with the lightness of the sky.

To emphasize the winglike trunk and Cat Woman-like taillights of this 1960 Chevrolet Impala, a ground-up shot was required. The result is a somewhat imposing image reminiscent of a vampire bat spreading its wings.

Close-Up Shots

Why should you shoot a close-up of a car? Sometimes intimacy is more seductive to the viewer than the whole ensemble. By focusing on a car's evident gems like the tail fin of a 1959 Cadillac Eldorado, an E-Type Jag's grill, or the rear lights of this '63 Corvette Coupe, close-ups can whet the viewer's appetite for more. At the same time, they say so much with so little. Plus, if you are shooting cars at an indoor show, close-ups can avoid the harsh lighting effects. Providing that the close-up is composed correctly, it can convey a wealth of information to the viewer, such as the era of the car, as well as its style, class, and personality. Beware of reflections off the car, including your own.

Often show cars are paraded behind velvet ropes, so tight framing is required using a zoom lens. Instead of using flash, bring a compact reflector with you. There is generally enough lighting at these shows to provide perfect illumination with the reflector without overexposing the subject with flash. If you can get close enough, use a macro, wide-angle, or even a fisheye lens with a tripod. All this equipment may seem awkward, but the result is truly satisfying. Besides, the cars are there to be admired.

Setting a Mood

Like with any good photograph, it is essential that you set a mood with your subject. With any "mood" shot, the composition is critical. Be as innovative as you can be by using irregular angles rather than just shooting the vehicle in a conventional horizontal or vertical format. I used a 45-degree angle to compare the evolution of three Pontiac Trans Ams. It gives the car another dimension without diminishing the respect for its power. Such angles add intrigue that can lead to show-stopping results or interesting documentation.

1976 Pontiac Firebird Trans - Am

1978 Pontiac Firebird Trans - Am

1979 Pontiac Firebird Trans - Am

The distinct, convexed front light display of a 1970 Pontiac GTO 455

Photographing Your Car

Let's say you want to take a close-up shot of your car to frame. Try not to diminish its appeal with a snapshot. Here are a few simple tips that can seize your viewer's admiration:

- Wash your car. It sounds ridiculously rational, but just look at used car magazines and see how many of the cars displayed aren't gleaming. Make sure there aren't any water spots. Make the paint seamless, the chrome dazzle, the tires sexy.

- Avoid the temptation to take the picture from eye level. Shoot from a ground-up, 45-degree angle to give the proportions of the car more impact. Otherwise, a lateral angle slightly above the vehicle, especially if it's a convertible, giving the car copious grandeur.

- Use a polarizer to prevent glare and reflections. It also increases color saturation to magnetic lushness and can improve contrast. Make sure you don't get your own reflection in the shot.

- Pay attention to the time of day. The best lighting conditions are usually right after sunrise or just before sunset. The light is generally warm, seductive, and forgiving—the complete opposite to midday sun that has a tendency to burn out top surfaces, cause murky shadows in the lower regions, and thoroughly bleach out cockpit and engine sections. Use flash during warm lighting conditions. It is also advisable not to photograph the car from the shadow side unless you compensate with flash.

- Don't forget, a car has personality, so make sure it is emphasized. It if is a muscular car, give it a streamline or powerful angle or from the ground up. If it a cute car, shoot it from a fun perspective. Finally, when you're shooting, turn your car's headlights on if it's just before dusk to add a little drama to your photos.

Find the angle that conveys the most about the personality of the car, such as the car's muscular dimensions, its curvaceous lines, its menacing prowl, or its elegant prowess. And it can all be done with close-up photography. Can you tell what these cars are?

Answers are at the back of the book.

Brawny curves and glaring air vents define its raw masculine dimensions.

The bulbous curves of unabashed joy depicting this marque's individualism.

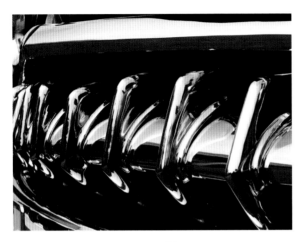

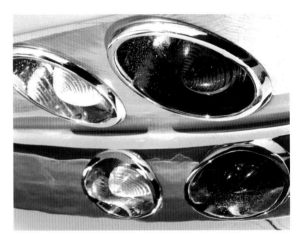

Its chrome grill just oozes with a menacing snarl.

Possibly the sexiest car of its generation in America. Bold, brash, and powerful.

Food Photography

Food is a wonderful subject to photograph because there is so much variety, so it is difficult to go wrong in choosing a product. However, there are ways to avoid making food look bland. Before you shoot, be aware of some key principles: you don't always have to shoot food at a 45-degee angle, subdue any shadows, pay close attention to your white balance and color casts, make sure the exposure and color rendering is correct, shoot in RAW, and use a tripod. In addition, try different lenses for more rewarding results, such as using a zoom or telephoto lens to focus at a specific detail. Like any other subject matter, find the most desirable angle that will make your subject irresistible:

- When photographing food (or beverages), make sure the background isn't vying for attention with the foreground product.

- It is key that you adjust the white balance to make sure everything is in its natural color. When shooting meat, fluorescent lighting can give it an anemic blue tinge when it should be shot in warm tones.

- Always try to use natural lighting. Avoid using flash directly on the food, as it is often too harsh. If you can't use natural lighting, use light diffusers or bounce your lights off a white board, wall, or ceiling. You can even use different colored plastic sheets or cellophane over your lights.

- Incorporate appropriate condiments, cutlery, and chinawear that will complement the setting and the subject. Try to keep the layout as simple and clean as possible.

- Everyone knows what an apple looks like, so give it some zing! Slice it, dice it, cut it, or peel it. Give it a whole new twist to catch your viewer off guard, as shown in the photograph below. The same applies to cake, meat, and sandwiches. Display more than simply the exterior of the product, especially with desserts.

- Food and beverages always look more appetizing using close-up photography. This style brings out the intimate texture, color, and finer details that encourage the viewer to savor the presentation.

- Citrus fruits, like limes, lemons, and oranges, have a translucent photographic appeal and are best sliced and lit from behind to bring out their lushness, while the layout can be lit softly with front lighting.

- Before you start shooting, take your time to examine what the best angles are for using various lenses and types of lighting. You may need to change everything with each angle. Try a zoom lens, a fisheye lens, and a macro lens.

- Brush on vegetable oil to make your food glisten.
- Apply glycerin to make sea-food appear as though it has just been brought in from the ocean.
- Hair spray makes an old cake look new again.
- Spray deodorant on grapes to give them that desirable frosty veneer.
- Brown shoe polish can turn a slap of raw meat into a roasted delicacy.
- Shampoo bubbles can be in place for coffee foam.
- Soaked cotton balls micro-waved, incense sticks, or smoke pellets can give off the appropriate "just out of the oven" steam effect.
- Motor oil can substitute for syrup.
- Make perfect-looking ice cream that won't ever melt with some mashed potatoes.

Photographing Fruit

Let's face it, fruit as a whole, isn't the most exciting subject. So how can you make a banana or lime more interesting? The advantage of fruit is often their radiant color. For example, place a green apple or banana on a plate whose color complements the fruit's color but make it as simple, almost stark, in contrast. Otherwise, cut a lemon or lime and backlight the intricacies by placing the citrus fruit on a glass or on a colored plastic sheet and light it from underneath or position it in a Ziploc plastic bag against a window.

Cut the fruit about a quarter of an inch thick. If it is too thickly sliced you risk ending up with a dark silhouette, and if it is too thinly sliced the light may be too strong to capture the maximum resplendence of the fruit's color. For an aesthetic shot, push the ISO as high as possible to give the image a grainy effect to accentuate the texture of the fruit.

Another method is to place a sliced lemon or lime in a clear, carbonated drink, like fizzy bottled water, and capture the percolated bubbles intertwined with the fruit. To accomplish this effect, fill a glass or a jar (for its flat sides) with ice to help keep the fruit in position. Place the glass either in front of a window or on your tabletop with a white, seamless background. Place one light source directly above the glass and another light source at a 45-degree angle above and in front the glass. If you place the lighting directing in front, you will get the light's reflection; if you place the light behind, you may end up with a silhouette shot (which could be also interesting especially with the bubbles in silhouette).

If you are using tungsten lamps, set your white balance to 3000K and bracket your shots. For those using flash, dial your white balance to the Flash setting. Turn the exposure mode to Manual mode and set the shutter speed to 1/125 of a second with an aperture of f/10 to start. Shoot with a tripod.

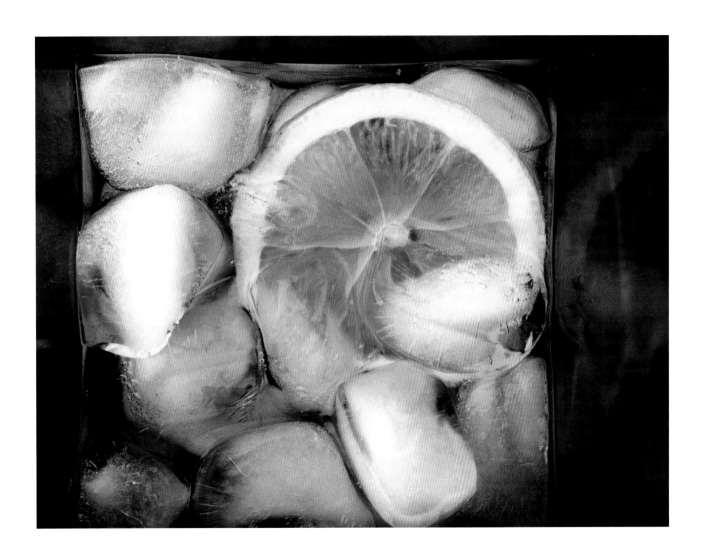

How to Photograph Falling Droplets

I have to admit that this is one of the trickiest shots to take. You have to consider focusing, timing, and lighting simultaneously. The result can be magical, but it may take minutes or hours to accomplish. Here is one method of preparation:

1. Get a container (like a cooking tray or a painter's roller tray, and black is better than white), and fill a quarter to half with water or coffee creamer or even paint.

2. Clamp an eyedropper or suspend a bag partially full of water (cream or paint), about 3 feet directly above the tray.

3. Position your camera on a tripod at a 45-degree angle aimed downward into the tray.

Use a macro lens and set it to Manual or Aperture mode.

4. If you use a flashgun, aim it at a white reflector or white board to bounce your light off it and have it projected toward the water/tray. If you are using tungsten lamps, you can either aim them at the reflective backdrop or position them at 45-degree angles behind the tray. Lighting hitting the water directly will give a flat appearance.

5. For those using a flashgun, set it to Manual mode and dial it to 1/16th power to freeze the motion as a starting point. The key is to get as much even light as possible.

6. If you are using an eyedropper, press a few drops out to see where they land on the tray. If you are using the bag technique, use a tiny pin and puncture a hole at the bottom of the bag and observe where the liquid lands. Then mark the area with a white pencil as the focal point.

7. You want the droplet to be as focused as possible. Start by setting the aperture to f/8, the ISO to 200, and the shutter speed at 1/200. If, for some reason, this isn't sharp or bright enough, experiment with the exposure until you are satisfied.

8. Take lots of shots and have patience. Try to shoot a split second after the droplet hits the water, not at impact. To make the shot even more interesting, add food coloring to the water.

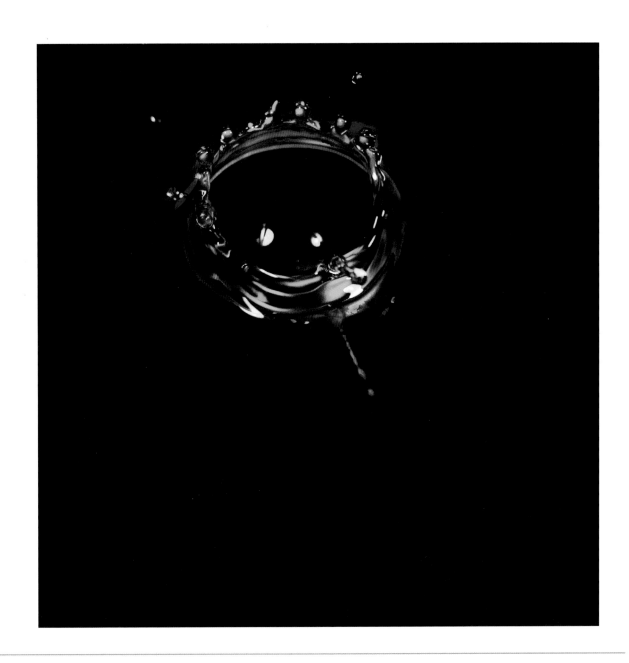

How to Photograph Smoke Trails

Smoke trails can be spellbinding; their ethereal, dancelike movements seem so harmonious. To capture smoke trails, follow these steps:

1. Use a black background and a solid base.

2. Use an incense stick. You can stand it in Plasticine or any other mold.

3. Close all windows. Yes, there may be a lingering scent afterward, but you don't want unnecessary breeze interfering with the shot.

4. If you are using a flashgun, place it behind the incense stick. Tape a black card to the side of the flashgun closest to the background. This will prevent flash from hitting the black backdrop.

5. If you are using a tungsten lamp, position it 2 feet to the immediate side (and slightly behind) the incense stick.

6. Focus on the tip of the incense stick to prefocus, and set your camera to Manual mode.

7. Set your shutter speed to 1/200 and your aperture to f/14.

8. The ISO is probably best at 200.

9. Set your camera to RAW.

10. Do a couple of test shots to check the exposure. You may need to bracket the shots.

11. Most of the smoke trails will be sinewy straight lines, so you will need to slightly shake the stick to get twirling trail motions.

12. Take 30 to 40 images then, once downloaded, you can manipulate them with color, angles, and so on.

13. Experiment with two or three incense sticks simultaneously.

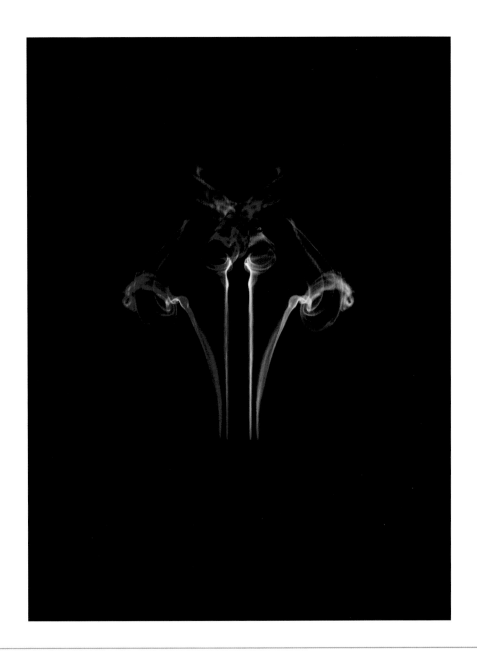

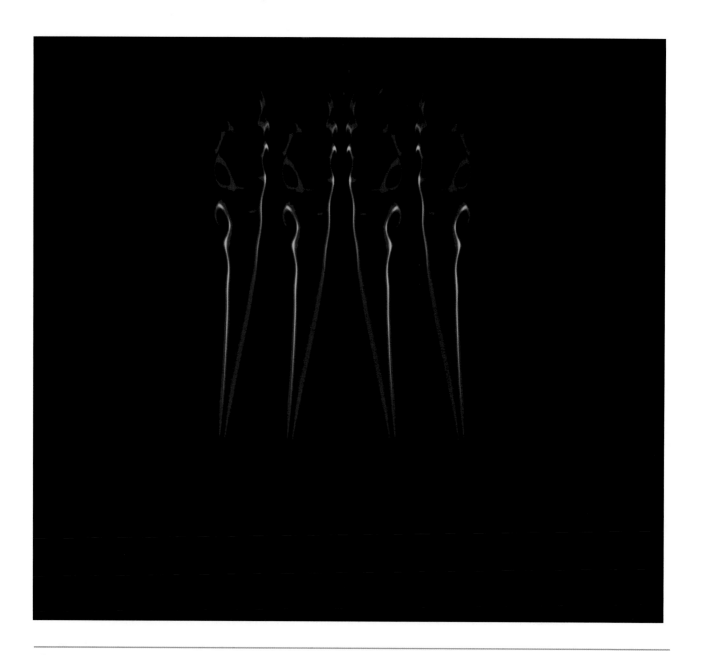

How to Photograph Lit Matches

The problem you may encounter with this particular shot is controlling the exposure—you are dealing with such a discrepancy of light: the lack of light before the match is lit, the explosion of light as it is lit, and the subdued lighting when the match is burning. Try the following steps:

1. To avoid the awkwardness of photographing your hand lighting one match with another, place either one or two matches standing up in Plasticine or sand, their heads bowed together. I say two matches for a greater burst of fire. Glue a thin string behind one matchstick.

2. Position your lights at an angle behind the matches.

3. Dial your camera setting to automatic exposure bracketing (AEB) to take three consecutive shots, allowing you to freeze the sudden explosion of fire.

4. Light the thin string and wait until it reaches the head of the match before shooting.

5. A note of advice: *Beware of fires.* Dispose of used matches in a bowl of water beside you. Keep a moist facecloth or towel near you for emergencies.

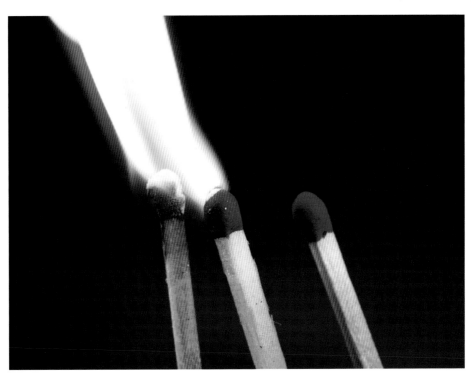

How to Photograph Water Refractions

This experiment can be a lot of fun using water droplets. Find something colorful, such as flowers; colorful candy like Smarties, bubble gum balls, rock candy, or jelly beans; polished pebbles; or a mixed bucket of coins. Then try the following steps:

1. Place the colorful objects in an open, transparent container, like a bowl or a glass vase. Place a black cloth for the container to sit on. Or instead of a bowl or a vase of flowers, place a photographic image of flowers facing up.

2. Position the camera over and parallel with the glass or clear plastic. Make sure there are no scratches or dust on the glass/plastic surface and that the glass is at least 4 inches or more above the objects in the bowl.

3. With an eyedropper, carefully arrange the droplets on the glass surface, possibly in a circular formation. Make sure the droplets don't touch each other. You want nice, bulbous droplets. If water doesn't work, try glycerin. It's oily but very effective.

4. Set your lights on both sides of the container with a white reflector at the back to help bounce the light back, illuminating the objects.

5. Position your camera, on a tripod, directly over the glass. Use Manual or Aperture focus.

6. Focus on the refracted images within the droplets—not the droplets' surfaces. Start with the widest aperture of f/22, and experiment with the shutter speed.

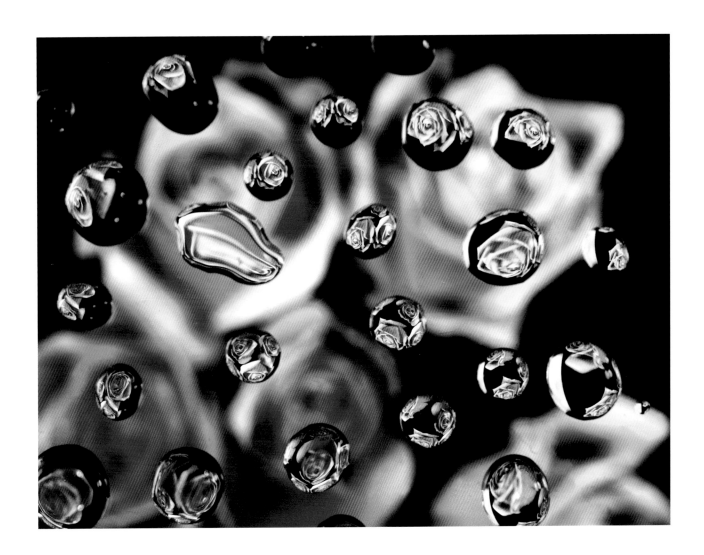

Photographing Water

Water is a wonderful object to photograph because of its reflective qualities and how it can magnify colors and textures. Water droplets have a penchant to magnify the surface texture that they lie on. In most cases of close-ups, to maximize depth of field it is best to keep the camera's sensor parallel with the subject. Be aware that the water pellets may reflect your own image, so you may want to use a longer lens. If this is the case, position your camera at an angle and use a small aperture to compensate for not being parallel with the subject.

Photographing Glass

Glass, like water, can create a plethora of reflective effects. Try photographing a whiskey, gin, or antique bottle where the letters of the name are embossed and take a close-up of a letter. Flash will be too strong, so place the bottle beside a window for natural lighting. Your shutter speed will depend on the outdoor lighting conditions. Position the bottle so that the shadow from the raised letters is evident—you will require side lighting. If the lighting from the window is too harsh, place tracing paper on the window to give an even light. Other forms of glass (or reflective material) worth photographing are jewelry, crystal, Jack Frost ice patterns on windows, and city lights off metal spheres, just to name a few.

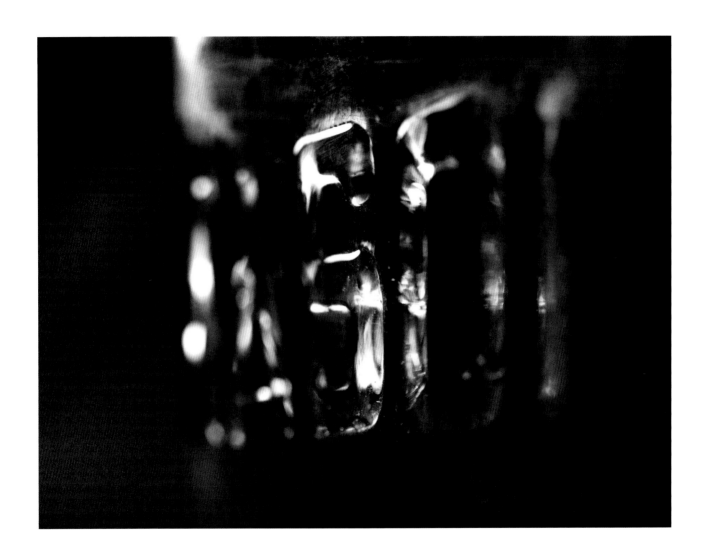

Photographing Synthetic Textures

The synthetic world can be just as illuminating as the natural world, especially when it comes to close-up photography. Find an old computer to dismantle and photograph the hardware, such as the computer chips, where a myriad of technological veins weave between geometric and regimented patterns. Again, depth of field is a concern, so be particular as to what you want to focus on, even when using Manual or Aperture focus. Keep your camera plane to the subject matter. Lighting is optional depending on how creative you want to be. For a flat, documentation shot, place your lighting in front and at a slight angle, but for a more aesthetic image, position the lighting low with severe angles to make the subject look almost alien with deep shadows. One light source should be sufficient.

Photographing Fabrics

Photographing texture defines the context of the subject. In the case of fabrics, it addresses the quality of the product without having to show the whole ensemble because they convey both visual and tactile sensations. To bring out texture, the light should be at an oblique angle. Finely textured surfaces need softer, more diffused lighting to highlight their qualities than do rough surfaces. Texture, as the example shows, is just as impressive in black and white as it would be in color.

Photographing Insects

I could watch insects for hours as a child. I would collect grasshoppers and house them in a large glass jar with blades of grass. Then, to their horror, I would find a praying mantis and add it to the group of grasshoppers. It wasn't so much that I was morbid; I was just curious to see how the mantis would react. It was like watching a snake strike a mouse. Although I find insects both fascinating and repulsive, many are blessed with a shimmering display of mesmerizing kaleidoscopic colors, like the eyes of a jumping spider or the abdomen of a long-legged fly.

Shooting Insects Outdoors

Because insects refuse to keep still for very long, I would recommend two strategies:

- Take your shots in the early morning hours. The hues are warm and complementary, and the insects are still awakening from their sleep, so movement will be slow.

- If you are patient and move slowly, you may be able to photograph insects with a macro lens, otherwise, the sight of a human approaching will inevitably scare an insect away. I would recommend a long lens (150mm +) to avoid this dilemma, and you can easily bleed out any distracting background.

Finding Insects

A good time to shoot insects is during the late spring and throughout the summer, but before you go off on some carefree jaunt, know the preferable insect habitats. For instance, bees and wasps will congregate around flowers for their pollen and nectar. Spiders have a desire for trees, branches, and old sheds. And stagnant water is like a singles' bar for untold breeders and hunters.

Attracting Insects

Now the tricky part. How do you attract insects? Try using an incentive such as honey, syrup, sugar water, or any sticky substance. Spread it on a branch or leaf or even smear it on a Petri dish, and wait to see what other insects emerge.

Documentation

If you are photographing insects for the purpose of documentation, it is essential to keep as much of the insect in focus as you can. There are millions of species—hundreds per family—and one family member has a different name from another simply because of a slight degree of color. Because insects don't carry around nametags, I would suggest investing in a reliable reference book for identification.

One recommendation is *Insects: Their Natural History and Diversity* by Steven Marshall.

What to Look For

Find out which angle is best suited for which insect. To give you an example, the tip of its abdomen can determine a species of dragonfly, and so can the venation running through its plastic-like wings. An insect with an extended antenna is usually a male, and a mosquito that bites is a female (she needs blood to nourish her eggs).

Shooting Insects Indoors

The depth of field for close-ups is minimal at best even using Manual or Aperture mode. Unless emphasizing a specific aspect of an insect, such as the eyes, keep the camera as plane as you can to the subject. Avoid using direct flash since most insects are too small to absorb such illumination. Either use incandescent lighting or bounce the flash off a white or silver reflector. Try to keep the lighting as even as possible to avoid deep shadows, so position the lighting on either side of the insect. Use a small aperture (high f-stop number), like f/16 or f/22 for maximum focus. The smaller the insect, the more reason to use an added accessory such as a bellows attachment. To steer clear of color shift from artificial lighting, use daylight-balanced lamps with a temperature of 5000K. You can also adjust your DLSR camera to this requirement.

Storing Insects

Insects are not known for their longevity. In fact, some only live for 24 hours. One way to preserve an insect is to store it in a refrigerator. This treatment won't kill it and its body temperature (and heart rate) will slow down to acclimatize to the new surroundings. Another "humane" way to kill an insect is by using the "killing jar" method. Take a glass jar with a lid that can close tightly. Cut out several layers of cotton, and place them at the bottom of the jar. Saturate the cotton with ethyl acetate (accessible from lab supply stores or hobby shops), and place the insect into the jar before sealing it. It doesn't take long before the insect expires. Happy hunting.

Abstract Photography

Abstract photography isn't about precision but about a different perspective on how we view the world. It is more about instinctual reaction than definition, communicating to the viewer's emotions. In essence, abstract photography relies on our more primal sense of form, color, and curves rather than function. It is also an ideal opportunity to experiment with close-up photography.

Train your eye to edit how objects are juxtaposed to each other, whether there is a nuance between shapes and texture. It is to your discretion whether you want precise focus, soft focus, or complete focus. There really are no rules. It is a raw, psychological form of art, not a documentary. What is so alluring about abstract photography is that you can take any everyday object, no matter how innocuous or bland, and transform it into something compelling.

Celestial Curtain (reflections from a CD)

The Final Hours of Hades (food coloring and water poured into a sink)

Adding Fuel to Fire (root beer being poured)

Iridescence
(the colors
inside a
seashell)

The Expulsion
of Memories
(oil paints
mixed)

Pink Ripples
(sheets of
rolled paper)

Adieu Paris (a
view from a
car's frosted
window)

Slow Motion
Riot (a mixture
of oil and water
on a metal plate
and dispersed by
a fan)

Chapter 6: What to Do with Your Images

Getting Published

Let us paint a scenario: You want to try and publish your images for a magazine. As a side note, most magazines are more susceptible to publishing work if images are accompanied by a themed text. The dilemma is to approach a topic with a fresh perspective. The public have preconceived ideas of what most things look like, so give it a twist by showing something unusual, educational, scientific, or spectacular. Consider the checklist below for close-up images:

- How do you want to tackle a topic?
- How should the image be composed in keeping with the article?
- How do you want to convey your message? In a sympathetic tone? Nostalgic? Documentation or conservational approach?
- How can you make it original and relevant?
- How can you make your image worth a thousand words?
- Is it topical or seasonal?
- If you know the nature of the magazine you submit your work to, does your work comply with its guidelines and readership?
- If your work is accepted, make sure your images are saved in the TIFF format at a high resolution (8 MB or higher, or a minimum of 4,850 pixels), ensuring that the clarity is sharp.

If possible, publishing your photography is easier if you can supply an accompanying article. Magazines prefer it because they only have to pay one person instead of two. Newspapers are another story. First, they prefer to let their existing staff do the articles, and second, there isn't a great need for close-up photography in photojournalism. They basically want the essence of the story in one shot. I did a photo exposé on skin and bones for the Canadian Medical Journal Association.

Documentation

Documentation is defined as the accumulation, classification, and dissemination of information which, in photography, could be segregated into the following subsections: archival, appraisal, demonstration and instructional, cataloging, and forensic. In other words, it's the mug shot style of photography. The main concern regarding photography for documentation purposes is to keep it simple. Do not have any distractions around the subject; sharp focus is mandatory, so use Manual focusing with the widest aperture possible, and bracket your shots by altering the exposure compensation or "EV." Use an even distribution of light. With small products, use either a light tent or set up a tabletop layout. A white background is generally preferable, for it allows the viewer to see more details and provides room for legible text to be inserted later. A black or dark background is more for glamour, brilliance, or aesthetic results, such as enhancing jewelry.

The light tent is a collapsible nylon dome or square that allows you to place your lighting at all three sides. The light is projected and bounces all around the tent, eliminating or softening unnecessary shadows. Otherwise, you can either construct or buy a tabletop layout that is equipped with four small tungsten lamps evenly distributed at angles aimed toward the base. The biggest difference between an amateur's product snapshot and a professional's product image is sharpness and lighting.

Below are three steps to ensure better product photography:

1. Focus on the subject using either Aperture priority mode or Manual mode with the widest aperture. The closer you get to the subject, the more limiting your depth of field will become.

2. Use a tripod to avoid camera shake. If you can, use a shutter release cable.

3. Use soft lighting. For soft lighting either shoot outside on an overcast day or use a light tent like the EZcube, or use a soft box. To photograph anything framed, make sure the camera is plane with the object. Do not use direct flash, particularly if the object is framed with glass. Use a white cardboard or other white surface to "bounce" light, so that a flash doesn't mar the image.

Whether you are photographing a flower, an artifact or antique furniture, know what is important

to document. Bring a pad and pen to report the specific names of the flowers, insects, etc. To avoid superfluous distractions, bring a small, white board to place behind the flower or insect. For images on artifacts or furniture (usually for catalogues or for assessment), photograph any detail for identification purposes including the signature (usually underneath the base), the fine finishes, underneath drawers or tabletops to verify that the piece wasn't upgraded.

Magazines

What is compelling about magazines is that there are so many of them on every imaginable subject matter. Most are colorful and well art directed. When approaching a potential magazine, find out the editor's name and what the magazine has a tendency to publish. If you believe your work would be accepted with open arms, write a neat proposal on a single page. Indicate the proposed title, a synopsis as to the topic, and how you define it as being different by indicating the contents broken down beneath a series of subheads. Don't inundate the editor with too much material (text and photos). Add your bio and if you've been published

elsewhere, and include samples to verify your experience. If you don't have a written article, numerous magazines have "Gallery" sections to exhibit submitted work, or inquire if the magazine might be interested in publishing a photo exposé on something topical. Magazines are always looking for topics to cover, so don't despair. I would suggest getting your hands on the latest edition of the *Photographer's Market* reference book (as well as the *Writer's Market* reference book) to help you decide whom to approach for your services.

Get That Shot

Spotlight On Nature

Tips For Photographing Flowers // Story and photography by Clive Branson

A garden is a place of discovery. Natural elements have an infinite effect — the time of year, time of day, the sun, the clouds, the rain, the fog and the wind — all influence the plants and flowers, which themselves are ever-changing.

Words alone cannot replace a good picture when it comes to floral descriptions. Like a portrait, a photograph is meant to articulate a flower's characteristics, heightening our awareness of their grace and beauty. However, we, unlike the camera, interpret what we see. There is an important distinction between what is beautiful and what is photogenic. The reverse is also true. A dying leaf may not be compelling, yet the same leaf can reward the photographer with a distinctly evocative image (fig. 1).

In mastering the photographer's craft, one must learn how to look at the world through the camera's eye. The purpose of this article is to introduce broad guidelines to help you develop a perception and understanding on how to get the most out on flowers. The ultimate satisfaction from nature's own beauty.

Filters

I tried to make a nondescript dried-up maple leaf a bit more intriguing. Neglected and lying on a pavement, I took it home, placed it on tarmac and poured some water into the flower's cavity. By using Photoshop to alter the original sterile color to a golden hue, the flower has come back to life in its alchemy-like transformation.

Book Publishing

These days, finding a publisher is very difficult. It is a high risk and investment for the publisher, who will want to make sure that either the topic or the author is a popular one. To publish a book on photography, go to a bookstore and write down the names of publishers from the various photo books on display and what they specialize in or favor. Normally, flower books don't sell very well, so (as mentioned before) come up with a unique way of expressing yourself.

Self-Publishing

Why might you want to self-publish your book? Either you can't afford to get an agent or no publishers seem to be interested in your work. I know people who have had moderate success and those who have had failure in trying to self-publish their books. Before you even consider spending money, a key issue to consider is whether your topic and the quality of your work will attract a viable audience? Does the topic have mass appeal? Of course, you are going to say yes, but just to make sure; ask around for feedback. If it appears that

people are genuinely enthusiastic about your product, look in bookstores to determine if others have published a book with a similar theme or approach to your idea.

Now, suppose you've decided to go ahead and self-publish your book. Writing the book will seem easier than the distribution of the final product. It's great to have your name on a book, but what's the point if you can't sell it? You generally have only minutes to try and convince a bookstore to accept it. If they do accept it, most bookstores generally want a hefty 40% or more of the take. Regardless, there are options to make a small profit, make a name for yourself, and build your self-esteem. Try publishers like blurb.com, viovio.com, asukabook.com,

dogearpublishing.net, or lulu.com. For a small price, get a minimum of your books printed and test the market. You won't be out of pocket and the consequences could be rewarding. Photographic bookstores and websites that promote self-published work are Dashwood Books in New York and Photo-Eye in Santa Fe. There is also The Independent Photobook website and the Indie Photobook Library. You can also try selling your book on your own website. This eliminates any financial split with a retailer, and purchases can be accomplished through PayPal. Above all, don't let financial rewards outweigh or cause you to sacrifice the enjoyment of your work. If photography is becoming a chore, choose another field of endeavor. It should be a passion, not a job.

> I contributed toward the design and photography of my friend's book, which has since been distributed in Spain, Mexico, Central America, South America, and Miami.

Stock Photography

Another way to earn money is to shoot stock pictures. If you can find a stock agency interested in your images, stock photography enables you to find a niche, develop your personalized style, and avoid having to shoot what some art director wants. If you do use a stock library, be aware that they may take up to a 50% commission. In turn, know what that agency relishes as far as what is popular.

So why go through a stock library instead of setting up your own stock library on a website? The stock agency already has an existing national or international reputation. It can reach, on a monthly basis, an incalculable audience including potential clients such as advertising agencies and design firms through mass marketing. You, on the other hand, don't have to pay the agency a cent, just produce great images—something you want to do anyway.

What's the difference between royalty-free and rights-managed images? People have a misconception that royalty-free images are free. That is incorrect. It means that a purchased image may be

used for several projects without you having to pay for the image each time you use it. The downside is that the client does not have exclusive use over the image.

A rights-managed image has a onetime charge for the use of a photo one time, and it can be purchased as an exclusive or nonexclusive photo. If the user wants to use the image for additional projects, the image needs to be relicensed, and the new use for the image has to be outlined. The rights-managed agreement allows multiple copies of the image for a specific purpose, but new uses need to be renegotiated.

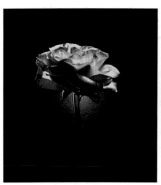

When submitting work to a stock agency, upload only what you think will sell, but keep a steady stream of images going per month. The stock agency will indicate what is warranted and what isn't.

- Do not send more than 30 on your initial upload.

- Don't use the image number as the description or caption. Describe the image in modest detail so that it can be placed in as many categories as possible.

- Do not try to sell any image of a private location, such as Hearst Castle, without written consent. You can photograph the place, but not for your own profit.

- Make certain your model release is witnessed so there won't be future legal disputes. This applies to children and portraits and sometimes to location sites. A third party must sign it. A model release is a legal binding document between the photographer and the model as to the photographer's intention of the shoot in agreement with the participating model.

Common Submission Mistakes

- The image is out of focus or fuzzy.

- The image has a watermark.

- The depth of field is too shallow. Clarity and focus are vital.

- Composition is poor and not well edited.

- The image has too much noise or is too pixilated.

- The image is in the wrong format. Only send images in JPEG format for the stock agency's initial review. Images accepted should be sent at 4,850 pixels.

- The image has been digitally processed too much. Avoid too much Photoshop work unless specifically requested.

- The image is lackluster. Your photos need to have that "pop" feel to them. Make sure your lighting technique is correct.

- The images haven't been categorized properly.

What *Not* to Shoot

This list is a guideline (applying to close-up photos) as to what kinds of images don't sell

because of poor quality, boring or unpopular subject matter, or oversaturation:

- Poorly lit shots (over- or under-exposed shots, including images with harsh burn marks).

- Close-ups of peeling paint, rust, old barn doors, and the like.

- Shadows.

- Your pet—unless it is exceptionally cute, very funny, or downright ugly. No shots of pets asleep.

- Artwork, artifacts, or a household object that couldn't be used in a generic way.

- Friends and family members. Instead, you want a professional, clean, and tidy portrayal of good-looking models in lifestyle scenarios, fashion close-ups, or shots that imply blissful weddings (e.g., locked hands showing the couple's wedding rings), broken marriages (e.g., a broken wedding ring), successful business transactions, or criminal action (a smoking gun, a used needle, etc.).

- Single flowers (you are better off approaching greeting card companies).

- Cars (unless they are of accident scenes, street racing, or depicting everyday drama).

- Images that are too abstract or too editorial, because they have little commercial value.

- Business people shaking hands. Anything contrived or set up, or any image that you've seen a million times.

- Architecture (usually the client will hire a professional photographer for such specific needs).

To acquire a good list of stock image libraries, pick up the *Photographer's Market* guidebook either from a store or a library. Be sure that you are submitting your images to a legit stock agency. Try to gather more information about the stock agency beforehand. Here are some stock agencies you may consider approaching.

Royalty-Free Stock Libraries

Micro stock libraries stay solvent by selling low-cost imagery and spreading the same stock through a chain of multiple agencies. Why should a client spend $300 for an image when the client can spend $3 or less for something similar? Although a photographer makes little on the sale of an individual image, the agency can sell the same images many, many times as compensation.

- everystockphoto.com
- morguefile.com
- stock.xchng.com
- fotolia.com
- freedigitalphotos.com
- photogen.com
- dreamstime.com
- pixmac.com
- backgroundsarchive.com
- corel.com
- Etsy.com
- DevianArt.com

Professional Stock Libraries

Before submitting any work to a stock agency, know the style of work the agency accepts and whether your work is similar in style and quality. Find out from the agency what it is in need of. Why send your best floral shots if they are simply going to be rejected? You may not sell many images through these agencies, but the rewards are good and you can make a name for yourself if your work turns out to be popular. Pete Turner made a living from stock photography in the 1970s.

- Comstock.com
- gettyimages.com
- jupiterimages.com
- veer.com
- corbis.com
- stockphotopro.com
- blendimages.com
- acclaimimages.com

Specific Stock Libraries

- flowerphotos.com
- gapphotos.com (floral photography)
- aflowergallery.com
- foodanddrinkphotos.com

If you are interested in simply showcasing your work and would like feedback, I would recommend flickr.com, betterphotos.com, or 500px.com as a start. Today, everyone has a camera, and stock libraries are recruiting photographers by infiltrating public photography websites such as flickr.com.

Greeting Cards and Calendar Companies

If you aren't successful with stock agencies, consider companies that concentrate on greeting cards, calendars, jigsaw puzzles, or even mouse pads. The best images are those that are universally acknowledged and can emit an emotional response. In addition, when you submit your images to a calendar company, send a series with a similar theme (New York City, hunting dogs, exotic cars, etc.).

Here is a list of companies that you may want to approach:

- www.workman.com (calendars)
- www.wymanpublishing.com (calendars)
- www.browntrout.com (calendars)
- www.teneues.com (calendars)
- www.trevillion.com (calendars)
- www.nouvellesimages.com (calendars)
- trendsinternational.com (calendars)
- www.pomegranate.com (greeting cards)
- www.nouvellesimages.com (greeting cards)

- www.artgroup.com (greeting cards)
- www.icon-art.com (greeting cards)
- www.canadagroup.com (jigsaw puzzles)
- ravensburger.com (jigsaw puzzles)
- pomegranate.com (jigsaw puzzles/calendars)
- whitemountainpuzzles.com (jigsaw puzzles)
- piatnik.at (jigsaw puzzles)
- springbok-puzzles.com (jigsaw puzzles)

Advertising and Promotion

When photographing, keep in mind how you fill the frame. Try to think in terms of what your image would look like as a poster or as a printed ad. Where would the headline and subhead be, and where would the text go? Is there enough room at the bottom for a logo? Is the picture too busy and cluttered? These are things that an art director must consider when reviewing images to use for a layout. This is why in advertising, negative space is always appealing. Try each shot in both horizontal and vertical formats. As a photographer, you would be given a mockup or an idea as to the feel of the campaign. The same applies for magazine and book covers. Ad agencies also expect all images in high resolution. Here are some of the ways close-up photography is used for marketing purposes.

you've loathed it.
you've screamed at it.
you've threatened it.
you've begged it.

it's your golf game.
need practice?

The Golf Academy
www.golflikeapro.com

Advertising:
Advertisers often use close-up photography as a means of being emphatic about a product or brand.

Posters: This was a poster for a fundraising fashion show. The marketing used humor in its approach to get a serious message across to a female target audience.

Menus: It is far easier to whet an audience's appetite (or thirst) with close-up photography than with a medium or long shot.

Books: Image is everything in marketing. Double exposure was utilized to make this cover intriguing and suspenseful.

Conclusion

Having your own style (and not simply being a carbon copy of others), enables you to unit a confidence that others, particularly these in the media, marketing, advertising and from galleries, will want to be associated with. When you develop a distinctive style, it is so much easier to sell yourself and be recognized.

I hope this book has given you, the photographer, some inspiration. I have always enjoyed photography because it is a creative outlet without too many barriers. Close-up photography enables you to explore a microcosmic universe and to showcase the transformation of the ordinary into the extraordinary by using something no one else has—your imagination. Enjoy.

Answers to the challenge on pages 140–141 in Chapter 5.

1. 2010 Dodge Challenger

2. 1974 VW Beetle

3. 1949 Ford Business Coupe

4. 1964 Chevrolet Corvette

List of Acronyms

A Aperture Priority
AE Automatic Exposure
AEB Auto Exposure Bracketing
CMYK Cyan, Magenta, Yellow and Black (four colours used by printers)
DLSR Digital Single-Lens Reflex camera
DOF Depth of Field
EV Exposure Value
ISO International Organization for Standardization
JPEG Joint Photographic Experts Group
LCD Liquid Crystal Display
M Manual Exposure
P Program Mode
RAW Raw data
RGB Red, Green and Blue (three colours used in digital image manipulation)
S Shutter Priority Mode
TIFF Tagged Image File Format

Index

Page numbers with "f" denote figures; "t" tables; "b" boxes.